IMAGES
of America

LARCHMONT

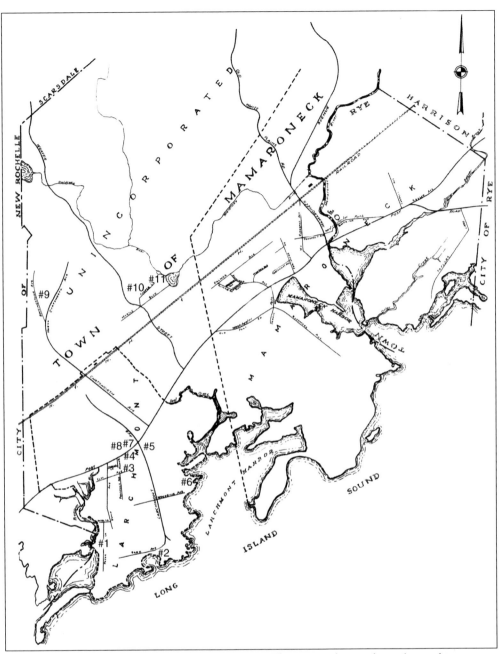

A MAP OF LARCHMONT AND MAMARONECK. This map shows the relationship among Larchmont Village(lower left), the village of Mamaroneck (right), and the unincorporated part of the town of Mamaroneck that has a Larchmont postal address. Larchmont Village and the unincorporated part of the town of Mamaroneck are the subject of this book. Historical sites indicated on the map are as follows: (1) Premium Mill and Pryer Manor, (2) Horseshoe Harbor, (3) the Manor House, (4) the Boston Post Road milestone, (5) the site of the Palmer farmhouse, (6) Larchmont Yacht Club, (7) the site of the 1711 Quaker Meeting House, (8) the Quaker and Barker cemeteries, (9) the Rockingstone, (10) the Palmer family graveyard, (11) Larchmont Gardens Lake, and the site of Mott's Spool Cotton Mill.

IMAGES
of America

LARCHMONT

Judith Doolin Spikes

ARCADIA
PUBLISHING

Copyright © 2003 by Judith Doolin Spikes
ISBN 978-0-7385-1300-3

Published by Arcadia Publishing
Charleston SC, Chicago IL, Portsmouth NH, San Francisco CA

Printed in the United States of America

Library of Congress Catalog Card Number: 2003107577

For all general information contact Arcadia Publishing at:
Telephone 843-853-2070
Fax 843-853-0044
E-mail sales@arcadiapublishing.com
For customer service and orders:
Toll-Free 1-888-313-2665

Visit us on the Internet at www.arcadiapublishing.com

This book is dedicated to my family—Jim, Katie, Sarah, Dommy, Dixie, Daisy, Sasha, and Skinky—and to the founding trustees of the Larchmont Historical Society (named on page 128).

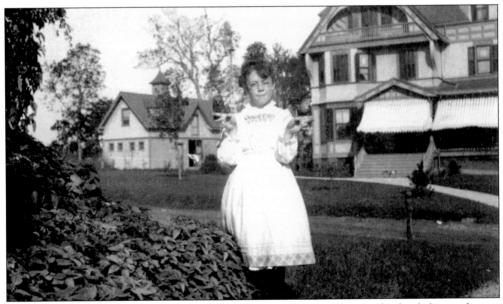

A LARCHMONT MANOR CHILDHOOD. Emma Fordyce shows off her pet birds while standing in front of her summer home on Maple Avenue in 1894.

CONTENTS

ACKNOWLEDGMENTS

Many thanks are due to the following: the 2003 board of trustees of the Larchmont Historical Society for permission to use material from the society's collection; Diane Holland of the Larchmont Historical Society Archives for refiling hundreds of photographs and documents; June and Deborah Allen for information about the Whites, Freemans, and Allens; Nora Lucas for her research on Larchmont subdivisions; Anne Marie Leone for the modern photographs on pages 10–11, 15, and 23–26; Ned Benton for his 2002 photograph on page 117 of children on the cannon in Flint Park; Cynthia and Kent Yalowitz for information about 59 Edgewood Avenue; Sally McGuire for information on the Fordyce family; Phyllis Wittner for information about the portal sign for the town of Mamaroneck; Mary McGahan for advice and support; and editor Pam O'Neil for her patience.

BIBLIOGRAPHY

Editorial Committee. *House Calls: The Larchmont Historical Society Holiday House Tours 1981–1993*. Larchmont: Larchmont Historical Society, 1993.

Editorial Staff. *Larchmont Shore Club at 75! 1925–2000*. Larchmont: Larchmont Shore Club, 2000.

Editorial Staff. *St. Augustine's Centennial 1892–1992*. Larchmont: St. Augustine's Parish, 1992.

Leone, Anne Marie, and Judith Doolin Spikes. *Larchmont Then and Now: A Photo History*. Larchmont: Fountain Square Books, 2002.

Lippsett, Paula. *Mamaroneck Town: A History of the "Gathering Place."* Mamaroneck: Town of Mamaroneck, 1997.

McGahan, Mary, and Judith Doolin Spikes, eds. *Larchmont Historical Society House Calls Vol. 2: House Tours 1994–2003*. Larchmont: Larchmont Historical Society, 2003.

Ogilvy, C. Stanley. *The Larchmont Yacht Club: A History, 1880–1990*. Larchmont: Larchmont Yacht Club, 1993.

Spikes, Judith Doolin. *Hometown History: A Primer of Local History Research with Emphasis on Larchmont, NY*. Larchmont: Fountain Square Books, 1991.

Spikes, Judith Doolin. *Larchmont, NY, People and Places: Pre-history to 1891*. Larchmont: Fountain Square Books, 1991.

The following sources were also used while researching and writing this book: the early issues of the *Larchmonter, Larchmonter Times, Mamaroneck Paragraph,* and *New Rochelle Paragraph,* and the articles of Phil Severin that appeared in the *Mamaroneck Daily Times* originally published in 1948–1949 and frequently reprinted. The sources listed in the bibliographies of *Hometown History,* and *Larchmont, NY, People and Places* were also consulted.

INTRODUCTION

From prehistory to the present day, it is the waterfront that has drawn people to Larchmont. In the spring of 1614, when the Dutch sea captain Adriaen Block sailed through the previously unbreached Hell Gate and along the western shore of Long Island Sound, he saw the fires of a Siwanoy fishing camp in what is now Manor Park. In 1661, the English–West Indian trader John Richbell struck a deal with two Siwanoy chieftains for access to three necks of land along Long Island Sound, apparently intending to establish a smuggler's roost between Dutch New Amsterdam and English Connecticut. By 1700, a Quaker farmer, Samuel Palmer, held title to the entire Middle Neck, which eventually became Larchmont.

The salt hay made it possible to pasture cattle without first clearing land and planting. Oysters, clams, and fish thrived in the marshland, and the streams not only provided fresh water without the need for digging a well but also made it possible to travel to the commercial centers in Mamaroneck, New Rochelle, and even across the Sound to Long Island before roads were laid out or ferry service established. The Palmers built a tidal mill on the site of the old Siwanoy fishing weir, where the Premium River empties into Long Island Sound, laying the foundations for a commercial milling industry. James Mott, the next owner of the mill property, built one of the largest flour milling industries on the East Coast after the Revolution.

At the same time, wealthy residents of New York City began to seek country estates to escape the crowding, heat, immigrants, and recurring epidemics of the city. Salt water and "salted" air were thought to be especially salubrious. Thus, the era of the country gentleman arrived in Larchmont. The largest such establishment was that of Peter Jay Munro, a nephew of John Jay who was raised in the Jay family.

The last person to hold this land as a country estate was the shipping magnate Edward Knight Collins. He bought much of Munro's land at auction in 1845, made extensive renovations to the house, and named his estate Larchmont. In 1860, he commissioned Frederick Law Olmsted—freshly famous for his design of Central Park—to survey his land and draw up a subdivision map. By the end of the Civil War, however, Collins's shipping empire had collapsed. Larchmont went on the auction block in 1865, advertised as "high, undulating and extending nearly a mile into the Sound, with unusual adaptability for building sites. . . . Those wishing to locate a first class watering place will find a combination of advantages probably not to be found elsewhere in the country."

Thus, the stage was set for the next step in Larchmont's evolution. A total of 288 acres of the best land was snapped up by Thompson J.S. Flint, a man with a checkered career who profited greatly during the Civil War. By 1870, he had become president of the Continental Bank and owned a town house on Madison Avenue, described at the time as "a palatial mansion." In preparation for his retirement to the country, Flint formed the Larchmont Manor Company in 1873 and began marketing the property as "suburban homes for businessmen of moderate incomes—say from $2,500 to $5,000 a year." But city dwellers proved uninterested in making permanent homes in the absence of amenities such as sewers, water mains, graded roads, gas lighting, schools, and the like. A few buyers of the type Flint sought did buy lots and put up summer cottages; somewhat later, several of these cottages were turned into boardinghouses, which attracted "a colony of the dramatic profession." With the financial panics of 1873 and 1879, development languished throughout the decade.

The establishment of the Larchmont Yacht Club in the Elegant Eighties made Larchmont

what it became in the Gay Nineties. As the club grew and world-class yachtsmen became members, the budding resort acquired fame and status and the lots began to sell merrily. In 1891, the Manor Company announced its intention to dissolve. By then, almost 1,000 people were living in Larchmont Manor—at least in the summer—and they wanted better streets, fire and police protection, sewers, and street lights. At that time, many of these services could not, by law, be provided by a town form of government, so the cottagers decided to incorporate as a village within the town of Mamaroneck. Three years later, the village of Mamaroneck was incorporated, leaving about six sparsely populated square miles of the town unincorporated. This unincorporated area subsequently acquired a Larchmont postal address and is included in this book.

Larchmont Village developed rapidly after incorporation, changing in ways its founders did not foresee. The clubby, intimate in-group, which was largely related by ties of blood, marriage, or corporate board membership and who solved problems quietly and settled disputes discretely, dissolved into political parties and neighborhood associations. The early 20th century brought paved roads, streetcars, automobiles, electricity, and faster and cheaper commutation to New York City. Development spread first to the part of the village that lay between the Boston Post Road and the railroad tracks. As the automobile became more common, commuters began buying homes farther from the station, or even drove to work. After World War I, the unincorporated area was rapidly subdivided. Commerce in real estate became Larchmont's largest industry—its only industry. Only one thing has remained constant from the time of the Siwanoys: the lure of the waterfront.

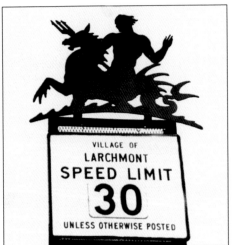 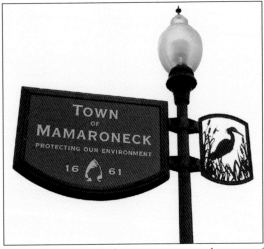

WELCOME TO LARCHMONT 10538. Larchmont Village and the unincorporated town of Mamaroneck share a postal address—Larchmont 10538—but have different governing bodies. Their boundaries are marked by portal signs. The Larchmont sign (left) was created c. 1940 by C. Paul Jennewein, a celebrated sculptor who lived in Larchmont for 53 years until his death in 1978. Among Jennewein's most important works are the large aluminum figures in the Department of Justice Building and two large sculptures flanking the entrance to the Rayburn House Office Building, in Washington, D.C., and the elaborate bronze entrance doors to the British Empire Building in Rockefeller Center in New York City. According to Jennewein's son, the sculptor chose Neptune as his subject for the Larchmont signs "because Larchmont is a waterfront community, and fishing was his favorite pastime." The town of Mamaroneck signs were designed in 1996 by Donald Meeker, a nationally known signage artist who is a current resident of Larchmont. In addition to the heron sign shown here, others feature waterfalls, trees, and bulrushes, emblematic of the many conservation areas within the town.

One

FROM PREHISTORY TO LARCHMONT MANOR

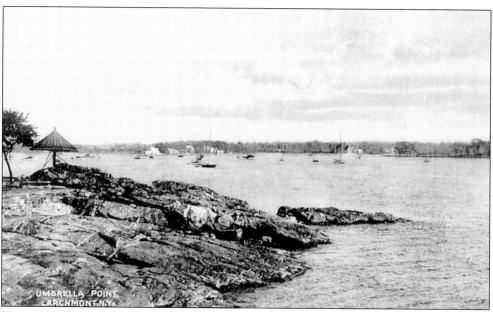

UMBRELLA POINT. In Manor Park near Umbrella Point, one glance shows the indigenous granite formed here some 360 million years ago and scraped bare by the glaciers. Also seen are the glacial erratics, boulders much older than the native rock—a billion years old, perhaps—brought by the moving ice from their homes in the Hudson Highlands and points farther north. The glaciers scratched the inch-wide parallel lines running north and south into the exposed strata underfoot.

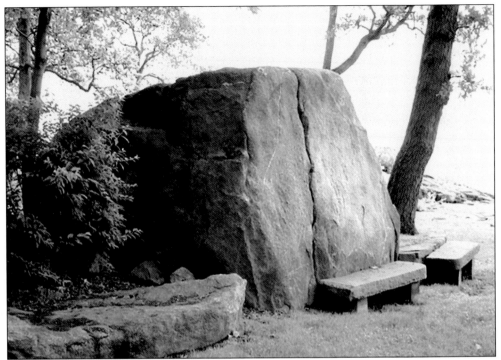

THE SLIDING ROCK. The Sliding Rock near the pumping station is a glacial erratic, whose side was rasped flat by the dragging of the glacier. (It has, in its turn, worn out the seats of blue jeans of generations of Larchmont children.)

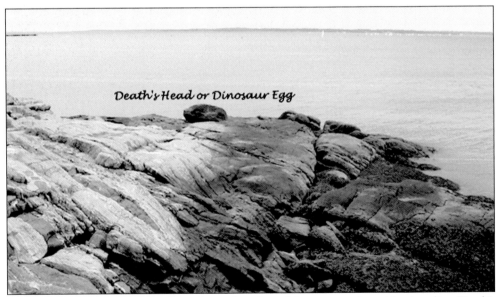

Death's Head or Dinosaur Egg

DEATH'S HEAD. Opposite the flagpole, at the edge of the water at low tide, the alien Death's Head (also known as the Dinosaur Egg) balances on native rock.

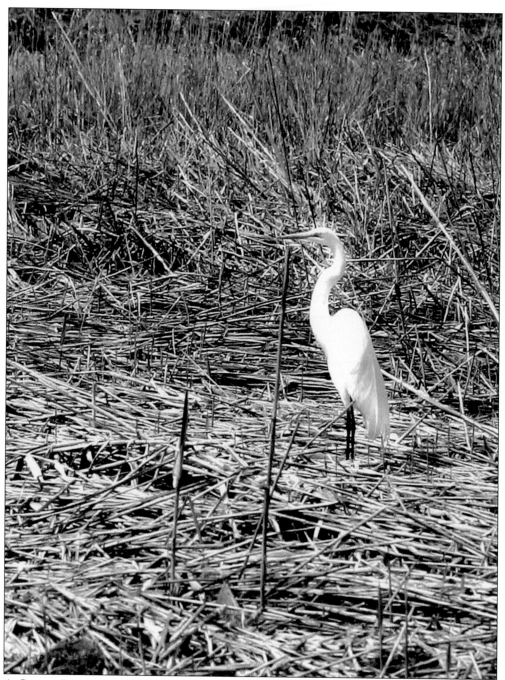

A Great Egret in the Marsh. After the final retreat of the glaciers, bays, estuaries, necks (peninsulas), and more intricate interdigitations of land and water fringed the shoreline as far inland as today's Boston Post Road. Erosion and silting, shorebirds with seeds in the caked mud on their feet, and sand washing in with the tide created marshes in these indentations. Until the latter 19th century, most of Larchmont Manor was a salt marsh, and much of the rest was freshwater swamp. Here, a 21st-century egret stands among native spartina grass in one of the few marshes left after 150 years of ditching, draining, and filling.

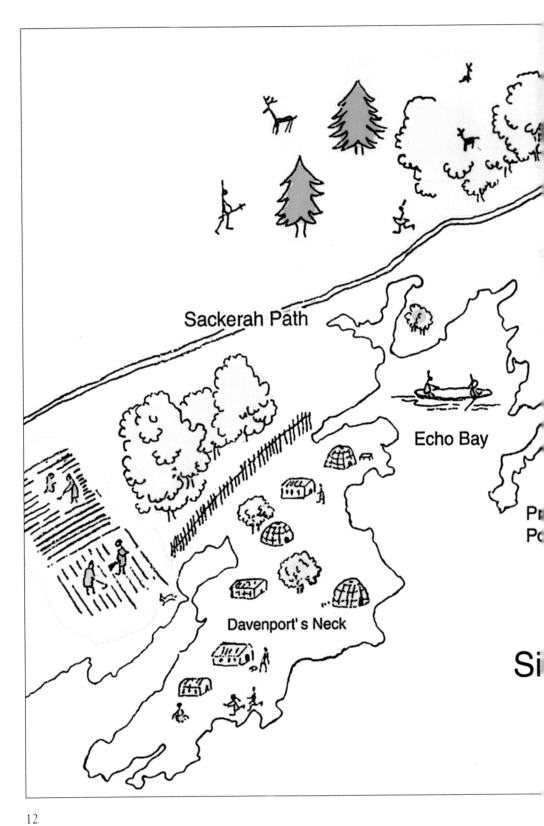

Sackerah Path

Echo Bay

Davenport's Neck

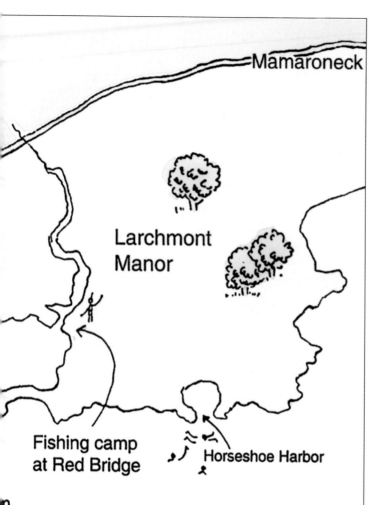

Mamaroneck

Larchmont Manor

Fishing camp at Red Bridge

Horseshoe Harbor

oys near Larchmont

By Judith Doolin Spikes

SIWANOYS NEAR LARCHMONT. In the spring of 1614, the Dutch sea captain Adriaen Block sailed through Hell Gate while testing his new cargo ship, the *Onrust*. This casual event marked the discovery of Long Island Sound. As Block sailed along the Sound's western shore, he saw campfires in Manor Park. They belonged to the Siwanoy, a peaceful people of the Algonquian language group who had a summer fishing camp at the mouth of the Premium River, where Red Bridge is now. Then, as ever after, it was the waterfront that drew people to this area.

AN INDIAN ROCK SHELTER, OR A PROFILE ROCK? This ledge at the southwest corner of Pinebrook Park, on Palmer Avenue, has acquired a popular reputation as the "Indian rock shelter." A decade or so ago, a team from Material Archives and Laboratory for Archeology conducted an extensive dig and found no evidence to support that notion. It is mentioned in early deeds as a landmark known as "the Indian rock"—and indeed, a really good imagination can discern a face in profile.

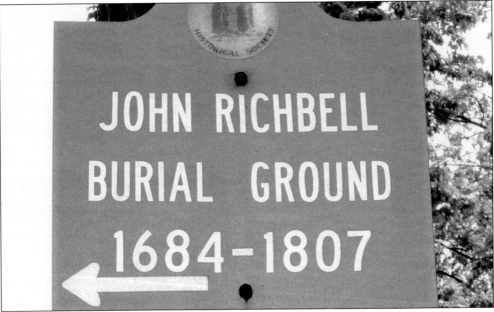

RICHBELL CEMETERY. In 1661, an English trader named John Richbell met two Siwanoy chieftains in Mamaroneck Harbor and struck a deal for three peninsulas, or necks of land, and adjacent land running indefinitely north of the Sackerah Path (now the Boston Post Road). In time, the Middle Neck became Larchmont Manor, and in 1891, additional land between the Post Road and the railroad was added to form the incorporated village of Larchmont. After 1894, when Mamaroneck Village (MV) was incorporated, the remainder of the town of Mamaroneck became known as the unincorporated town of Mamaroneck (TOM), sharing a postal address with Larchmont Village. This sign, to the left of 408 Rushmore Avenue in Mamaroneck Village, points to a waterfront meadow with no discernible grave sites.

LARCHMONT, 1716. In 1700, Richbell's holdings on the Middle Neck passed into the hands of Samuel Palmer, a Quaker farmer born in Connecticut. Palmer and his wife, Mary Drake, built a pioneer home near the site of the Larchmont Public Library. This land comprised almost exactly the same square mile that today forms the village of Larchmont. Palmer was the first supervisor of the town of Mamaroneck. After his death in 1716, his land passed in equal parts to sons Sylvanus, Solomon, Nehemiah, and Obadiah, with each receiving one parcel above and one below the Post Road. Over the next 60 years, most of the settlers who came to join the Palmers on the Middle Neck were also Quaker farmers.

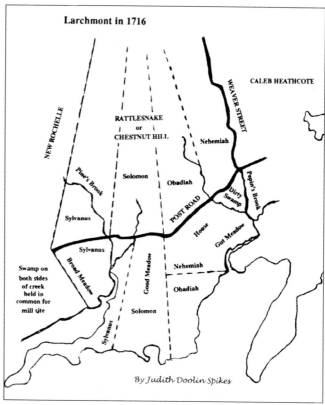

Larchmont in 1716

By Judith Doolin Spikes

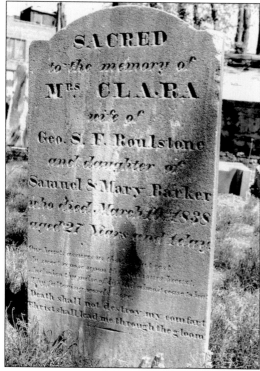

A QUAKER TOMBSTONE. In 1704, the Palmers secured official permission from the Crown to hold Quaker meetings in their home, and they donated land for a Quaker burial ground north of the Post Road diagonally opposite their home. The burial ground remains (along with an adjacent cemetery for family members who "married out"), with nothing but simple fieldstones to mark the early graves. Shown is an extant tombstone from a later period, when inscribed stones were no longer considered idolatrous.

CALEB HEATHCOTE. Arriving in America c. 1619, Caleb Heathcote became a prominent man in New York, holding many offices, including colonel in the Westchester County militia and mayor of New York City. He began making large purchases of land in Westchester and, in 1696, took the first steps toward creating the Manor of Scarsdale. This eventually included the land that became the unincorporated town of Mamaroneck, but not Larchmont Village. Scarsdale Manor remained intact until sold by Heathcote's heirs in 1775.

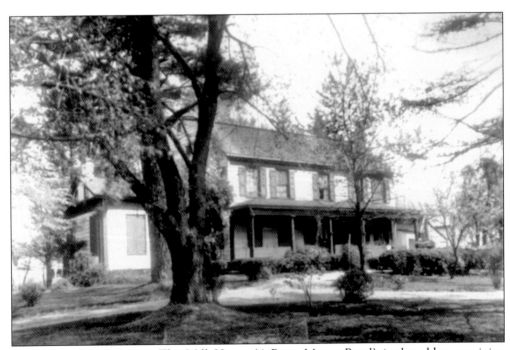

THE MILL HOUSE, 1903. The Mill House (4 Pryer Manor Road) is the oldest surviving structure on the Middle Neck. Although much enlarged and altered over the years, the original portion is believed to have been built c. 1775, probably by Samuel Palmer's grandson John, who sold the house, a barn, a gristmill, and 120 acres to James Mott on July 7, 1776.

JAMES MOTT. Great-great-grandson of John Richbell, James Mott was a wealthy Quaker merchant and preacher living in New York City when the Revolution began. Because his wife, Mary Underhill, was ill and their children very young, he decided to move to the country where he thought life would be more peaceful.

JINNY AND BILLY. As it turned out, Mary Underhill Mott died soon after moving to the Mill House, and the four young children were left to grow up "in the perils of a border land between hostile armies," cared for by their maternal grandmother and two former slaves of the family, Jinny and Banjo Billy.

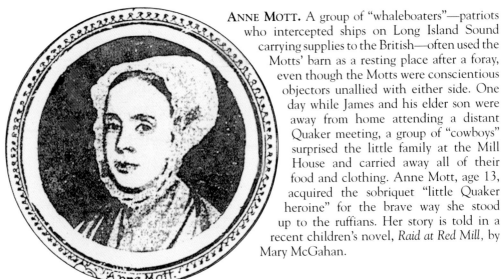

ANNE MOTT. A group of "whaleboaters"—patriots who intercepted ships on Long Island Sound carrying supplies to the British—often used the Motts' barn as a resting place after a foray, even though the Motts were conscientious objectors unallied with either side. One day while James and his elder son were away from home attending a distant Quaker meeting, a group of "cowboys" surprised the little family at the Mill House and carried away all of their food and clothing. Anne Mott, age 13, acquired the sobriquet "little Quaker heroine" for the brave way she stood up to the ruffians. Her story is told in a recent children's novel, *Raid at Red Mill*, by Mary McGahan.

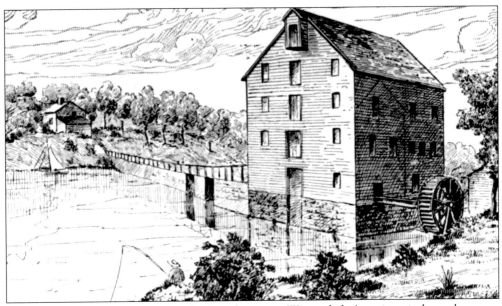

PREMIUM MILL. A few years after the Revolutionary War ended, American industry began to prosper. In 1804, Robert and Samuel Mott bought from their father Mill Pond, the adjacent house, and some surrounding land and built a big new mill at the mouth of the bay. With more waterpower and 12 runs of stones, the Motts soon had the largest flour-milling industry on the East Coast, producing Premium flour for export to Europe. However, between the embargo on shipping abroad imposed in 1807 and the War of 1812, the Premium Mill failed and the Motts moved away.

LUCRETIA MOTT. The older Mott son, Richard, followed in his father's footsteps and became a well-known Quaker preacher. He built a mill to produce cotton thread on his farm on the Sheldrake River, in the unincorporated town of Mamaroneck, near what is now Hickory Grove Drive. In 1814, James's grandson James II and his wife, Lucretia Coffin (whom he had met at the Quaker boarding school Nine Partners, of which his grandfather was headmaster), moved to Hickory Grove to help Richard Mott. The business soon fell on hard times, however, and the young couple moved to Philadelphia to be near her parents. There, Lucretia Mott became a world-famous abolitionist and suffragist.

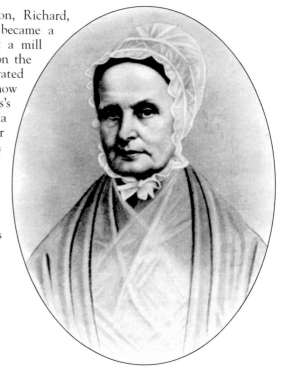

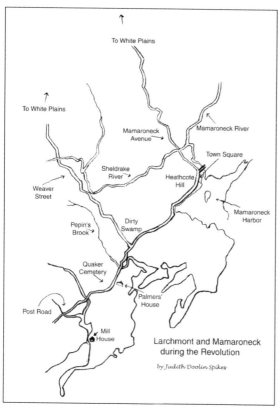

LARCHMONT-MAMARONECK, 1776. This map shows the entire town of Mamaroneck, including the future villages of Larchmont and Mamaroneck, at the time of the Revolution.

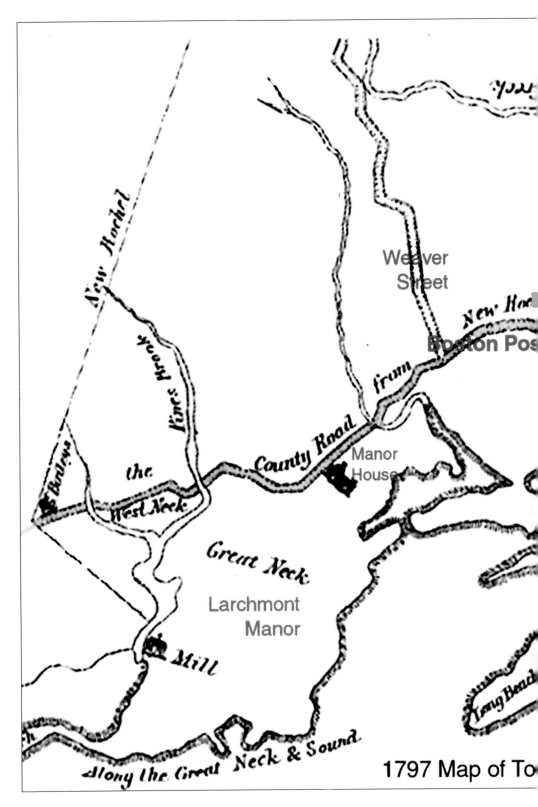

New Rochel

Weaver
Street

New Hoe

Boston Pos

from

County Road

Manor
House

the

West Neck

Bridge

Vines Brook

Great Neck

Larchmont
Manor

Mill

Long Beach

Along the Great Neck & Sound.

1797 Map of To

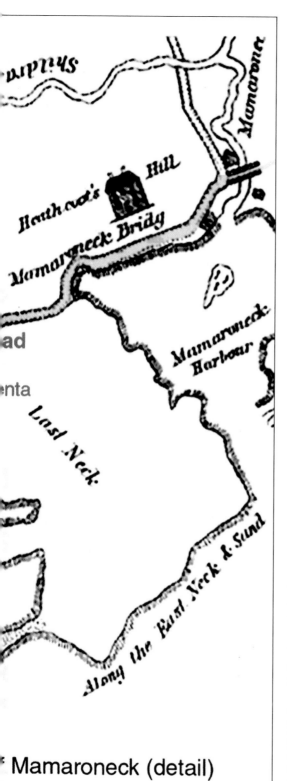

Mamaroneck (detail)

LARCHMONT, 1797. The depredations of patriot and loyalist armies, "cowboys" and "skinners," and raiding parties from Long Island caused most shore dwellers to abandon their ruined farms and move to places of greater security in the interior of the county or farther upstate. The census of 1790 found only 11 family units on the Middle Neck (village of Larchmont), and a lesser but indeterminate number in the unincorporated town of Mamaroneck. This map was drawn by Edward Delancey from a manuscript map found in state records at Albany, with some additional captions by the author.

21

PETER JAY AND MARGARET MUNRO. In 1795, Peter Jay Munro bought the Samuel Palmer homestead, and by 1828, he had acquired all of the Middle Neck below the Boston Post Road (except the Mott property) and much of the Palmer purchase above the Post Road. Munro was the son of a Scotch clergyman who returned to Britain during the war, abandoning his wife, Eve Jay, and young son to the care of Eve's brother, John Jay of Rye. Munro served his uncle as secretary during the negotiation in Paris of the peace treaty with Britain, and upon returning to the United States, he became a lawyer after apprenticing in the law offices of Aaron Burr. With Burr's assistance, he eloped with Margaret White, the daughter of a prominent family who had spurned his suit.

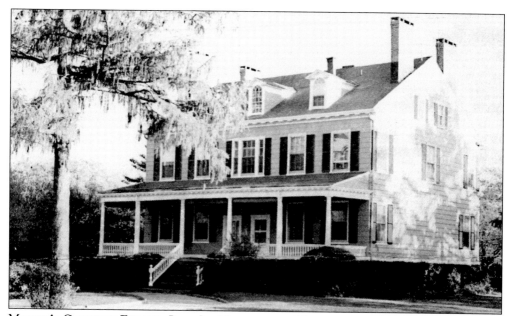

MUNRO'S COUNTRY ESTATE. Peter Jay Munro yearned for a country estate like that of his Jay relations, and c. 1797, he built the big house on the little hill that still stands at 18 Elm Avenue. This photograph shows the house as Munro built it—facing the Boston Post Road. The next owner remodeled the rear elevation into the facade, facing towards Long Island Sound.

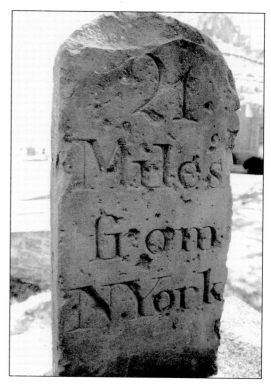

A POST ROAD MILESTONE. In 1800, Peter Jay Munro joined John Peter Delancey, Cornelius Roosevelt, and other prominent politicians and businessmen in forming the Westchester Turnpike Corporation to lay out a toll road from New York City to Connecticut along the route of the Boston Post Road. The old Post Road (since 1673, the first official post road in North America) was merely the Siwanoy footpath widened and straightened to permit the passage of a traveler on horseback, a small cart, or since 1722, an occasional stagecoach.

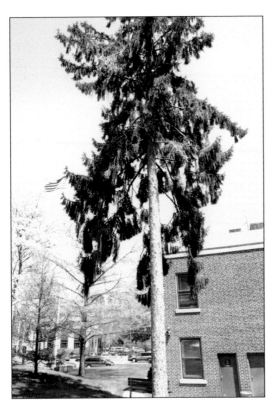

A LARCH TREE. The route of the old road was greatly altered when the turnpike was put through, setting the course of the Post Road as it runs today. The wider, straighter road was "paved" with gravel, and the increased traffic raised so much dirt and noise that Peter Jay Munro planted a row of Scotch larch trees to screen his house from the nuisance. Fast-growing but short-lived, none of the trees that gave Larchmont its name survives today. Pictured is a relatively recent exemplar planted between the Post Road and Larchmont Village Hall.

A BONNETT AVENUE SIGN. Street names are all that are left to mark the tenure of any of the other, and lesser, country gentlemen of the early 19th century. In 1820, Lloyd Saxbury Daubeny bought from the Palmer assignees 82 acres above the Boston Post Road in the area later known as Larchmont Park and now as Pinebrook. Daubeny was a seafaring man and the husband of Peter Jay Munro's niece Susan Titford. Some 10 years after Daubeny's death in 1847, the estate was sold to Patience Bonnett, a member of an old New Rochelle Huguenot family, for whom Bonnett Avenue, a quarter of a mile east of this area, is named.

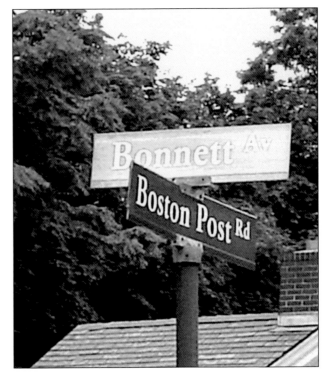

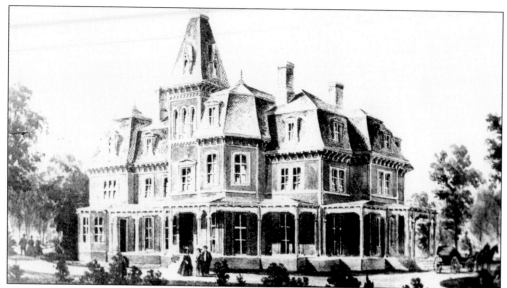

THE MYERS COTTAGE, OR CHATSWORTH INN. The Daubeny-Bonnett property was acquired in 1863 by James Van Schoonhoven Myers, a prosperous wholesale dry goods merchant from Brooklyn. Myers and his wife, Mary, built a 29-room cottage some 200 feet north of the Post Road where Beach Avenue is now located. After Myers died, the house was operated as a summer boardinghouse known as the Chatsworth Inn. The building was razed in 1903, when the property was sold for development.

A ROOSEVELT AVENUE SIGN. In the early 1840s, James John Roosevelt (a brother of Peter Jay Munro's turnpike partner, Cornelius Roosevelt) purchased property from Peter Jay Munro's sons and others and assembled a 500-acre farm that stretched from the Post Road between the Daubeny estate and what is now the eastern boundary of the village and running along the railroad tracks and up into New Rochelle.

A VANDERBURGH AVENUE SIGN. In 1850, James Roosevelt and his wife, Cornelia Van Ness, sold 28 acres bordering the Post Road to Mary E. and George Vanderburgh. George Vanderburgh was a resident owner, not a country squire. He was an incorporator of the Westchester Historical Society, and he served the town of Mamaroneck as inspector of elections, as assessor, and in several other capacities through 1879. The Roosevelts sold the remainder of their 500-acre farm in 1853 to George F. Jackson, a principal in the Chatsworth Land Company. The Vanderburgh homestead was operated for some years as a summer boardinghouse until it burned to the ground with all its outbuildings in 1883, before there was any firefighting organization in the area.

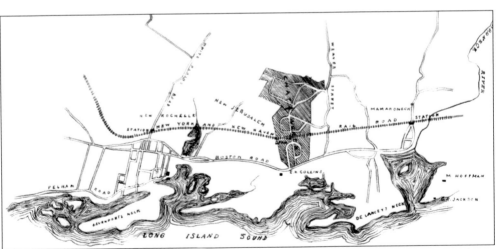

A DETAIL FROM THE CHATSWORTH SUBDIVISION MAP. The New York and New Haven Railroad made its first run through Larchmont on December 25, 1848. Although it was many years before Larchmont was more than a whistle stop, the iron horse revolutionized travel from the city and initiated the process that changed all of this area from rural farmland to suburban garden plot by the end of the 19th century.

THADDEUS DAVIDS. Believing that land near rail transportation would bring a good price, Thaddeus Davids (an ink manufacturer and owner of Davids Island in New Rochelle) and George R. Jackson (a partner in an iron-mining company) bought the old Roosevelt farm in 1853 and formed the Chatsworth Land Company to develop it. They named the subdivision after the country seat of the English dukes of Devonshire and marketed the property as suburban homes for what would then have been called the "middling classes"—small merchants, tradesmen, mechanics, and the like.

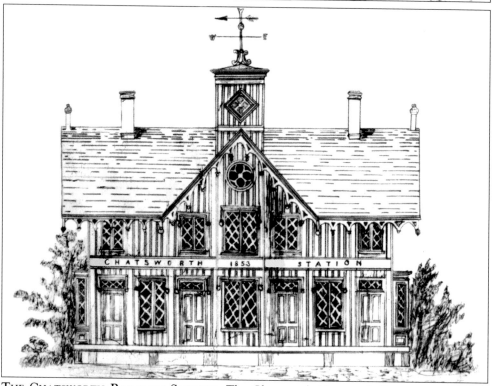

THE CHATSWORTH RAILROAD STATION. The Chatsworth Company's first act was to erect a small Gothic-style railroad station. Its second act, a year later, was to engage an engineer, William Bryson, to survey the land and draw a subdivision map.

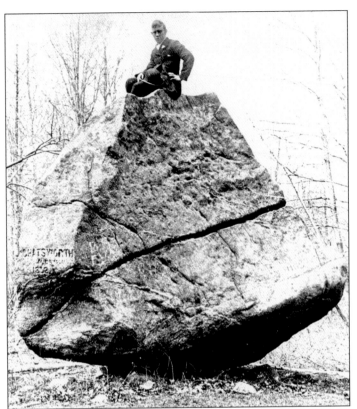

THE ROCKINGSTONE. When William Bryson finished the survey, he carved his name, the name of the company, and the date into an 11-foot-high, 150-ton glacial erratic on the property. The boulder is known as the Rockingstone because, until settled by blasting in the early 20th century, it was so accurately poised that it could be rocked without falling over. The photograph was taken c. 1915; the drawing is a detail from the Chatsworth subdivision map.

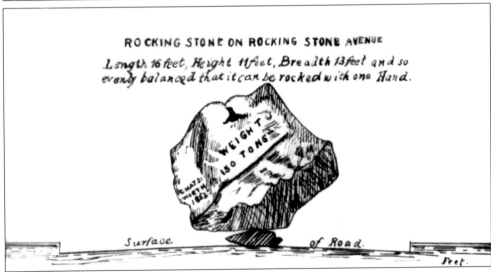

ROCKING STONE ON ROCKING STONE AVENUE

Length 16 feet, Height 11 feet, Breadth 13 feet and so evenly balanced that it can be rocked with one Hand.

WEIGHT 150 TONS

Surface of Road.

Feet.

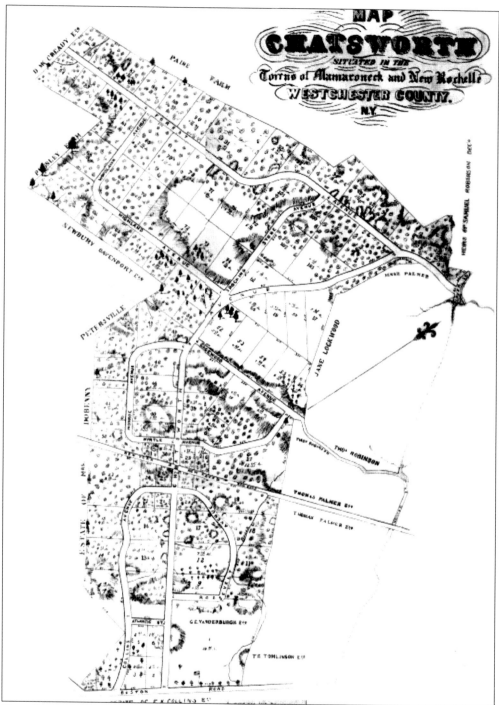

THE CHATSWORTH SUBDIVISION MAP, 1854. Homeowners were not attracted to an area without gas lighting, public water and sewers, fire and police protection, schools, and other amenities they were accustomed to in the city. The Chatsworth land was finally sold in several large parcels, most of which remained farmland, orchard, pasture, meadow, and woodlot until well into the 1890s.

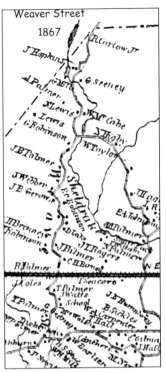

Weaver Street
1867

WEAVER STREET, 1867. To the east of Chatsworth lay several large farms (all in the unincorporated town of Mamaroneck). The names of seven landowners in this area appear on the Chatsworth map. North to south, they are Samuel Robinson, Jesse Palmer, Jane Lockwood, Thomas Robinson, Edwin Willcox, Thomas Palmer, and T.E. Tomlinson. Access was from Weaver Street, which has been described as "one of America's oldest highways." This 1867 map shows many more landowners in the area. It is believed that the thoroughfare took its name from a community of weavers, probably French Huguenots from New Rochelle, who set up their looms near the intersection with the Boston Post Road, possibly as early as the late 17th century.

THE QUAKER MEETING HOUSE. Much of this area was the inheritance of Nehemiah Palmer, and through the years, Palmer and his descendants built a number of mills—saw, grist, cider, and spool cotton—along the Sheldrake River, while others farmed small holdings into the 20th century. The Palmer presence brought other Quakers to the area, and c. 1768, the Quaker Meeting House was relocated from its original site near the Palmer homestead on the Boston Post Road to a site on Weaver Street just south of today's Griffen Avenue. After the dissolution of the Mamaroneck meeting between 1902 and 1905, the original meetinghouse became a gardener's cottage and is said to remain in an unrecognizable state at 1006 Fenimore Road. The 1828 meetinghouse, pictured here, was purchased by the Scarsdale Historical Society and moved to that municipality.

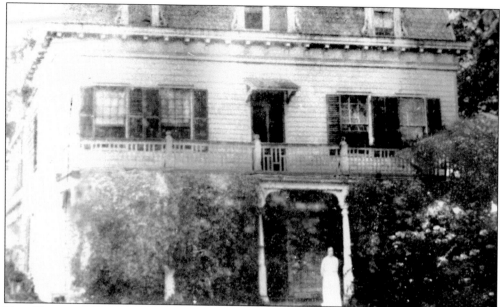

THE HOWELL MANSION. Thomas Palmer, another descendant of the original settlers and a wealthy candy and tortoiseshell-comb manufacturer in New York City, remodeled an old inn overlooking Weaver Street into a 40-room mansion *c.* 1845. There, in a 40- by 20-foot dining room and a drawing room of similar proportions, he entertained with elaborate dinner parties, balls, and private theatricals. When a road to Mamaroneck was laid out across his property, it was named Palmer Avenue in his honor. Upon his death in 1886, the property passed to his Howell relatives, who early in the 20th century subdivided the estate as Howell Park. The house was razed in 1941, after the death of Palmer's niece Ella Howell, who is shown here, standing in front of the house *c.* 1940.

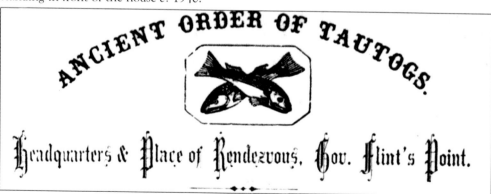

A TAUTOG CLUB INVITATION. Thomas Palmer—along with Thaddeus Davids and others—founded the Tautog (an Indian name for blackfish) Club, an association of New York City businessmen with country homes along the Sound who devoted their leisure hours to fishing. The club broke up during the Civil War because of the members' highly divergent political opinions but eventually "the hatchet was buried" and the "jollifications" resumed, according to Ella Howell. This invitation to a monthly meeting goes on to say that the "Club will provide for a permanent dancing floor in Sylvan Grove, with appropriate music for dancing. Croquet will be in demand, and those having sets will oblige by bringing them. Members having *vocal* friends will not forget to invite them especially" and is signed by the secretary, George E. Vanderburgh.

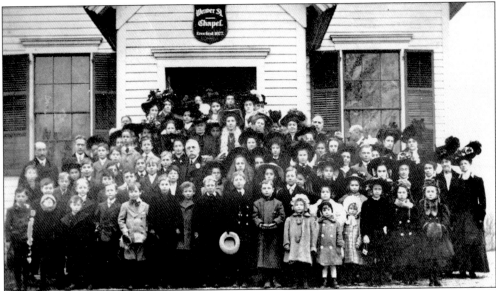

THE WEAVER STREET CHAPEL. The congregation of the Weaver Street Chapel was founded in 1863 to meet the needs of area Protestants who found the Sunday journey to established churches in Mamaroneck Village or New Rochelle too long and arduous. The chapel itself was built in 1877 and is shown here in 1909. By the time it burned to the ground in 1926, membership had dwindled to almost nothing—due to the automobile, which made commuting to church services elsewhere quick and easy—and thus, it was not rebuilt. Weaver Street was subsequently partially relocated to run through the chapel property, and the high rocky ground on which the chapel had stood was leveled at that time. Today, a garden and a plaque mark what is left of the chapel site.

THE WEAVER STREET SCHOOL. The first public school in the area was constructed in 1807 on Weaver Street opposite the Palmer-Howell mansion. Originally a one-room schoolhouse, it was expanded over the years and, in 1881, was serving 63 students. The building continued to serve as a primary school until 1922. It was converted to a residence in 1925 and still stands at 84 Weaver Street.

GRANT'S FLORIST. Grant's Florist and Greenhouse, next door to the Weaver Street School at 96 Weaver Street, was established in 1887 by the English-born gardener-landscaper George Grant. As a sideline, Grant boarded summer residents' large ferns, palms, and other potted plants during the winter months. Grant's was Larchmont's oldest business when it was suddenly demolished in 2000 to be replaced by two houses. Shown is an early view, before the long greenhouse was built on the front of the Grant family home.

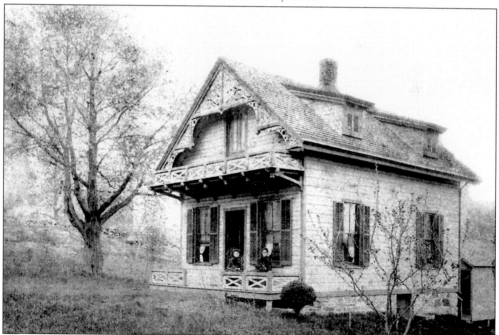

THE HOUSE AT 102 WEAVER STREET. The Coriell family built this fanciful gingerbread house in 1876. The Coriells operated "Rockledge Farm—Fresh Eggs" out of their barn. In 1921, D.W. Griffith selected this house as the setting for a scene from the film *Orphans of the Storm*. Shorn of its gingerbread and other ornamentation, the house still stands at 102 Weaver Street.

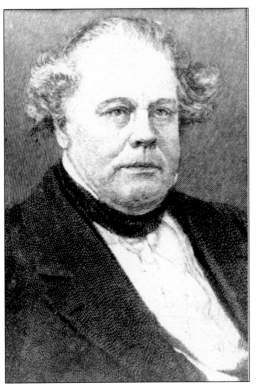

EDWARD KNIGHT COLLINS. During the years that the Chatsworth Land Company was trying to develop its land above the Post Road, the world-famous shipping magnate who gave the village its name bought all of Peter Jay Munro's land below the Post Road (1845). He was Edward Knight Collins, who secured the first transatlantic U.S. mail contract and built the first American steamships to cross the Atlantic. One of the wealthiest men in New York, he was known as "the Yankee lord of the Atlantic Ocean."

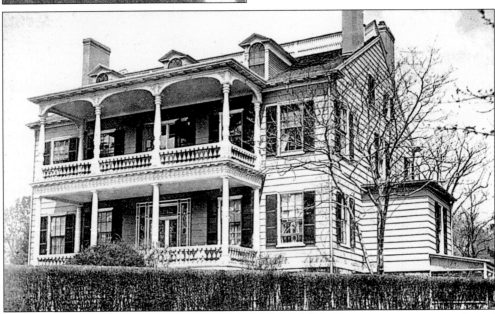

THE NAMING OF LARCHMONT. Edward Knight Collins added an ornate two-story veranda and an enormous ballroom to the rear of Peter Jay Munro's Federal-style house, and he reoriented the interior so that the public rooms no longer faced the Post Road but overlooked a long "prospect" sloping down toward Long Island Sound. (This later became Prospect Avenue.) Then, inspired by the row of larch trees along what was now the back side of his property and by the slight rise of land on which the house stood, he named his estate Larchmont.

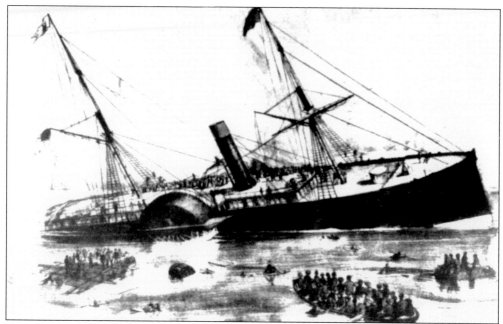

THE *ARCTIC*. Edward Knight Collins's ships were the most luxurious on the seas, and they were the fastest on the Atlantic run. However, in the mid-1850s, the Collins Line suffered a series of disasters. The *Arctic* sank off Cape Race in 1854 with more than 300 passengers aboard, including Collins's wife and two of their children. In 1856, the *Pacific* sailed from Liverpool and vanished without a trace. Seven months later, Collins's congressional subsidy was withdrawn. In 1858, his remaining ships were sold at auction to satisfy his debts.

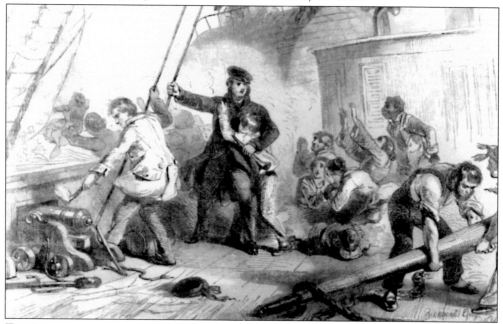

THE WRECK OF THE *ARCTIC*. As a deck hand lights the cannon distress call, the ship's captain stands firm at his post while his son clings to him in fear. Desperate passengers leap overboard or crouch on deck.

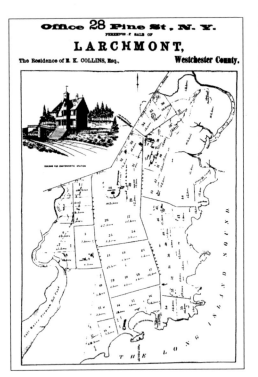

Office 28 Pine St. N. Y.

LARCHMONT,

The Residence of E. K. COLLINS, Esq., Westchester County.

THE COLLINS'S ESTATE, SOLD AT AUCTION. In 1860, Edward Knight Collins commissioned Frederick Law Olmsted, famous for his recent design of Central Park, to survey his estate and lay it out in building lots. The estate Larchmont went on the auction block on June 10, 1865. The land was described as offering "unusual adaptability to building sites all in full view of the Sound and East River. The entire property is finely shaded, and the extensive lawns around the mansion have arches and avenues of superb trees of half a century's growth."

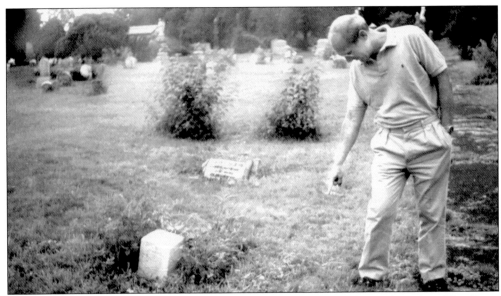

COLLINS'S GRAVE, WOODLAWN CEMETERY. Edward Knight Collins is buried in Woodlawn Cemetery in the Bronx, a borough of the city he helped make the world's greatest port. He lies in an unmarked grave because for years after his death his sons and his second wife were so busy quarreling over his will that nobody remembered to order a headstone. Larchmont does not even have a memorial to the man who gave it its name. Soon after the village was incorporated, the thoroughfare known as Collins Avenue was renamed Larchmont Avenue. The photograph shows his grave site (which the author and her husband located in 1992 after half a day's search). It is Lot 1, Range 2, Grave 26.

Two

FROM SUMMER RESORT TO INCORPORATED VILLAGE

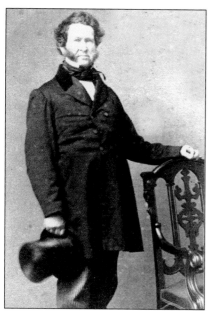 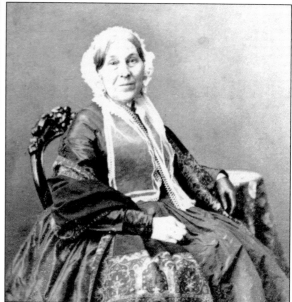

THOMPSON J.S. AND ELIZABETH FLINT. Thompson J.S. Flint, a New York City banker, prepared for his retirement by buying most of Edward Knight Collins's Larchmont estate at auction. Seven years later, he had 288 acres subdivided and formed the Larchmont Manor Company to develop the property as "suburban homes for New York City businessmen of moderate incomes," according to an 1872 announcement in the *New York Times*. Flint and his wife, the former Elizabeth James of Pekin, Illinois, are shown here in 1865.

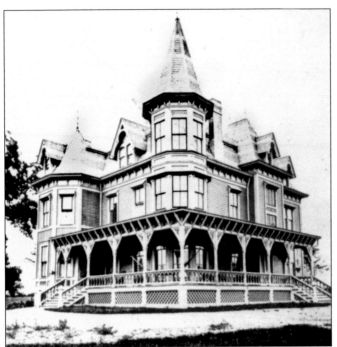

THE FLINT HOMESTEAD, 1872. For their own homesite, Thompson and Elizabeth Flint chose a prime piece of waterfront property on a landscape feature known as Oak Bluff and named it Matlock, according to Flint family lore, after their ancestral home in England.

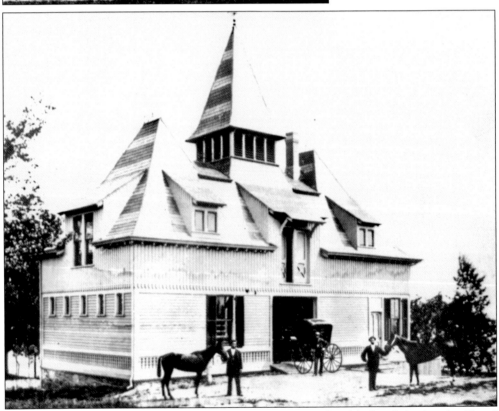

THE FLINT CARRIAGE HOUSE, 1872. A driver, groom, and stable hand display the Flints' carriage and fine horses. Both Matlock and the carriage house were destroyed by fire in 1904.

HELENA, ADELE, AND FREDERICK W. FLINT, C. 1880. Three of the Flint children were long and closely associated with Larchmont, and none more closely than Helena. She built three splendid houses in Larchmont Manor, reclaimed Cedar Island from marshland, donated the Hosmer sculpture that is the centerpiece of Fountain Square (itself the centerpiece of the Larchmont Manor), and, when she moved to California in 1915, left to the village five acres of land on its eastern boundary that was subsequently annexed to the village and developed as Flint Park.

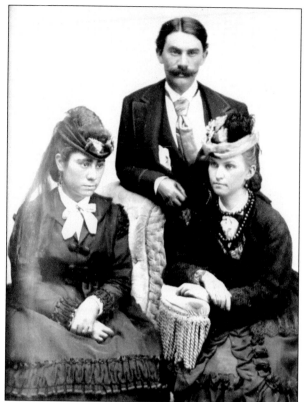

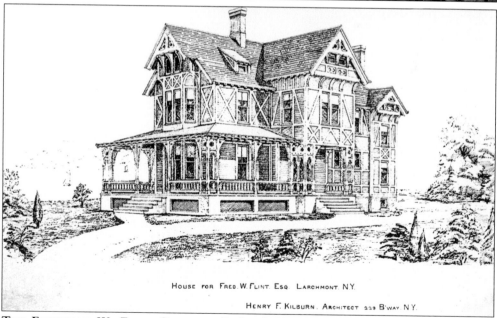

HOUSE FOR FRED. W. FLINT. ESQ. LARCHMONT. N.Y.

HENRY F. KILBURN. ARCHITECT 229 B'WAY. N.Y.

THE FREDERICK W. FLINT COTTAGE. Frederick Flint (1852–1908), the youngest son of Thompson and Elizabeth Flint, built this summer house near that of his parents in 1877. It was moved and reoriented on its large lot in 1923, and it served from c. 1915 to 1925 as the Oak Bluff Hotel. The house remains, much altered, at 2 Oak Bluff Avenue.

CHERRY TREE COTTAGE, BUILT IN 1894. This 18-room dwelling at 85 Larchmont Avenue was the second residence constructed by Helena Flint. Its dining room is paneled in cherry, raising a supposition that the lumber came from the property and gave the house its name. Helena Flint also built Spring Cottage next door (no longer extant), 62 Magnolia Avenue, and an early-20th-century home on Cedar Island that was razed when four imposing Tudor-style residences were built there in the 1920s.

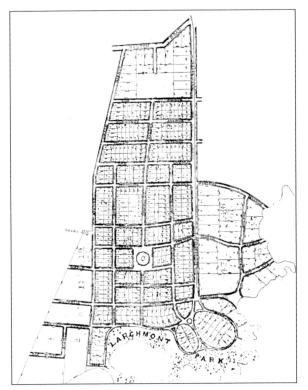

MAP 610. The Manor Company replaced the Collins subdivision plan with one that set aside most of the waterfront to be held in common by those who bought lots in Larchmont Manor (Map 610). Thus, every household had access to the water, a major selling point, and—most important—Larchmont gained its exquisite waterfront park, an unrivaled asset that still sets it apart from otherwise similar communities along the Sound. This design was created by Frank Ellingwood Towle.

THE STAG ON THE GLACIAL ERRATIC. "The scenes of my childhood are kept green in my memory by the descriptions often repeated by my mother, who never ceased to hallow the place of her early married life. My parents bought a little house at the turn of the road, down by the park, early in 1872 and moved in there permanently. I particularly remember a bronze stag which stood in the park in those days, a very real friend of my early years." Thus wrote Eugene McJimsey Richmond (born in Larchmont Manor on February 12, 1873) in his memoirs. The stag was stolen in the 1960s, but the glacial erratic (the Sliding Rock) on which it stood remains.

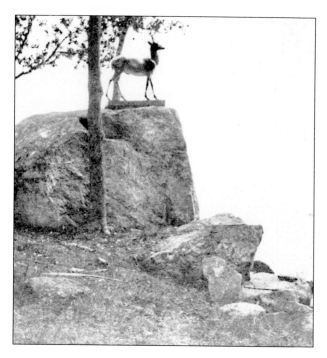

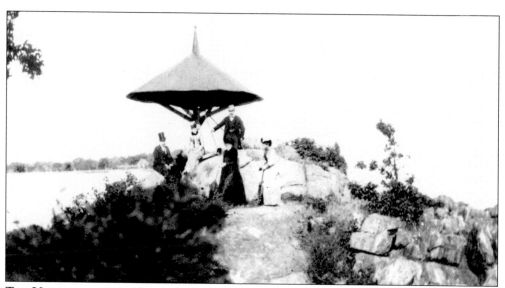

THE UMBRELLA, 1870. The Umbrella in Manor Park has been repaired so many times that it is doubtful if any of the original structure remains. It is the most recognizable symbol of Larchmont.

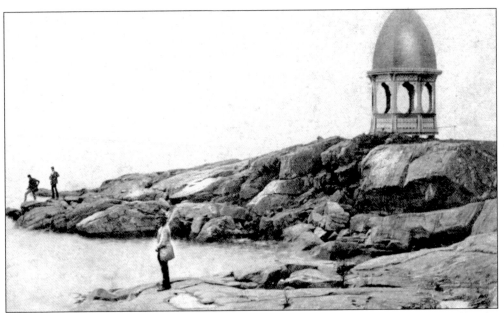

THE FIRST PAGODA. The first shelters in Manor Park, then styled pagodas, were erected by the Manor Company in 1873 but were so weakened by age and weather that they were replaced in 1897 by "Greek-style summer houses."

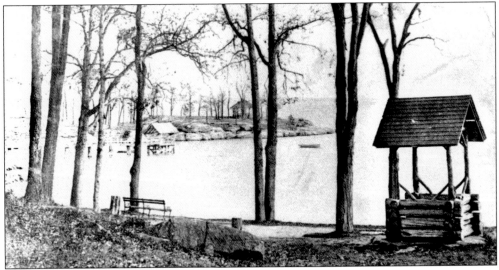

THE WELL. By the time this photograph was taken, the old well near the bathing beach was more decorative than functional. The wells and cisterns that supplied the cottagers with water in the days before the Larchmont Water Company was founded (1889) were less picturesque. Water was raised by "armstrong" pump to rooftop storage tanks, from which it flowed into basement kitchens. The shallow wells sometimes failed during dry weather, and the Manor Company found it necessary to cart water in barrels from house to house. This old well was filled in and sealed in the 1930s because "children threw things into it, polluting the water," according to the minutes of the Manor Park Society. The superstructure was replicated by the Larchmont Historical Society in 1996 according to plans by local architect James Fleming and dedicated to Susan Spencer Merolla, a past president of the society who died an untimely death.

THE FIRST BATHHOUSE, 1873. The first bathhouse was torn down in the spring of 1892. David Jardine, a summer resident and the architect of several now landmarked buildings in New York City, designed a large new pavilion for the 1892 season.

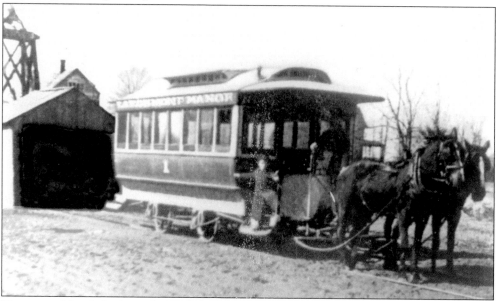

HORSECAR NO. 1. In the early 1870s, "a conveyance met the trains (a sleigh in snowy weather) over which Owen Sweeney presided," memoirist Eugene Richmond recalled. "He was a welcoming character, an Irishman of inexhaustible good humor and droll wit." Owen Sweeney became the first driver for the Larchmont Horse Railway Company, which got under way in 1873, conveying commuters from the old Chatsworth Station to Larchmont Manor. The first horsecar barn, shown here along with Horsecar No. 1, stood at the corner of Larchmont and Cedar Avenues. The latter was built twice as wide as other cross streets to accommodate a turnaround at its dead end on Grove Avenue.

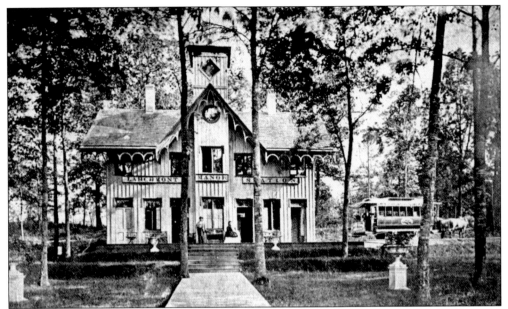

LARCHMONT MANOR STATION, C. 1873. This view of the old Chatsworth Station shows the name has been changed to Larchmont Manor. Note the horsecar at the right.

THE MANOR HOUSE. After a four-track railroad line and a large new station were built in 1887, the Manor Company turned the old Munro-Collins mansion into a hotel, christened it the Manor House, and sponsored special train excursions from the city and overnights for prospective buyers. The Manor House also served as a clubhouse for Manor property owners and offered lodging to their overflow guests. Eugene Richmond noted in his memoirs that he treasured for more than 80 years the memory of the "delicious ice cream" served at the Manor House.

THE GINGERBREAD COTTAGE. The Manor Company's initial offering included six summer cottages, as well as building lots. Cottage No. 2, now known as the Gingerbread Cottage, was purchased in July 1872 by the family of Frank Ellingwood Towle, shown here enjoying a refreshing saltwater breeze on the porch. Mrs. Mary (Sibell) Towle, later recalled that "the Manor was almost treeless in those days but for a grove of cedars on the present Manor Park and a few lonely oaks and elms. The land between Beach and Circle avenues from Willow Avenue to the waterfront was a marsh. A stream of water ran through this and rippled down the present route of Park Avenue into the Sound near our bathing beach." The family, whose New York City home is today the landmarked Mount Vernon Hotel Museum, at 421 East 61st Street (formerly the Abigail Adams Smith Museum), returned to this cottage for 50 summers.

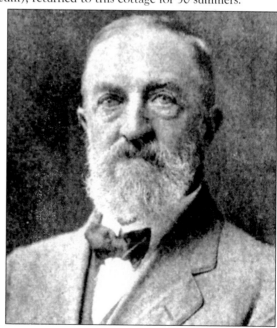

FRANK TOWLE. When the Manor Company became dissatisfied with Edward Knight Collins's original subdivision plan, it asked Frank Towle, an engineer and surveyor employed by the city of New York, to make a revision. The result was Map 610. Towle was the son of Jeremiah Towle, also a city engineer who had worked with Frederick Law Olmsted in laying out Central Park and who long served as New York City parks commissioner. Towle's naturalistic design of Manor Park was doubtless influenced by the master.

45

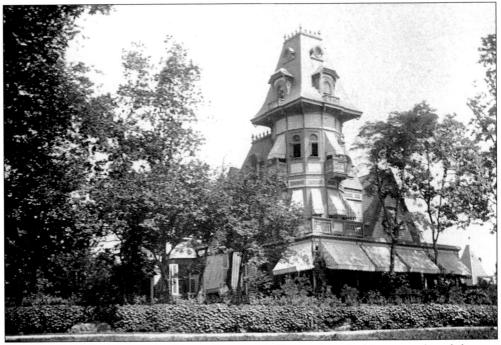

THE PROCTOR COTTAGE. The Manor Company's Cottage No. 1, this mansard-roofed tower house at the corner of Park and Prospect Avenues (90 Park Avenue site), was built in 1872 and purchased by Leonard J. and Isabel Smith. Frederick F. Proctor, the famed vaudeville czar, bought the cottage from the Smiths in 1887 and razed it in 1927.

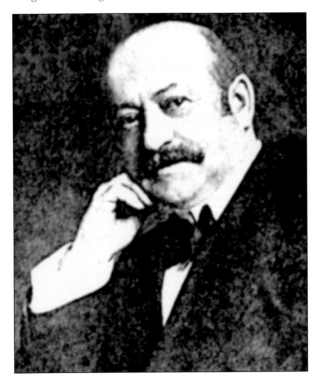

FREDERICK F. PROCTOR. Two years after Frederick F. Proctor bought his summer home in Larchmont, he opened Proctor's 23rd Street Theater and, in collaboration with Arthur Frohman, brought the greatest stars of vaudeville to its stage. Flush with success, he moved on to create his famed theater chain. His theaters were highly popular because of their "genteel and wholesome fare, suitable for the entertainment of women and children, as well as men." At the peak of his career, Proctor owned some 50 such establishments, and 12 of them were sold to RKO for approximately $18 million just before his death in 1929.

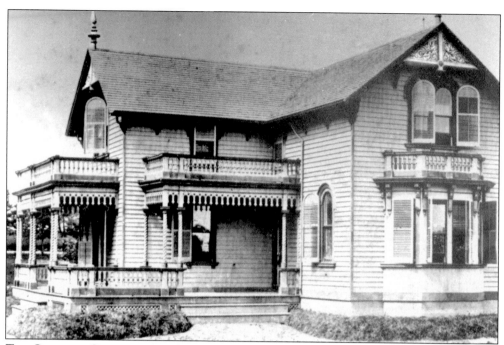

THE CLAXTON COTTAGE. Another of the original Manor Company cottages was built at 108 Park Avenue, where it remains in a much altered state today. Originally purchased by Victoria Hallett, wife of realtor William Hallett, it was bought in 1894 by Kate Claxton, a member of the Augustin Daly troupe and one of the most popular stage stars of her time.

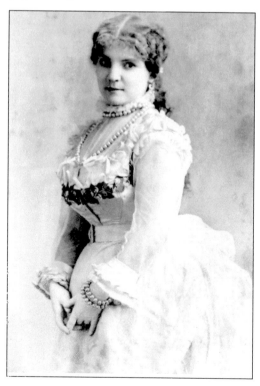

KATE CLAXTON. The great Brooklyn Theatre fire of 1876 occurred during a performance of *The Two Orphans*, with Kate Claxton in the starring role. Another Larchmont resident appearing in the play, Claude Burroughs, was among the 295 persons who perished. Kate Claxton survived with only minor injuries, but it nearly destroyed her career: a few weeks later, the hotel in which she was staying burned to the ground, causing superstitious actors to refuse to appear with her and theatergoers to cease attending her performances.

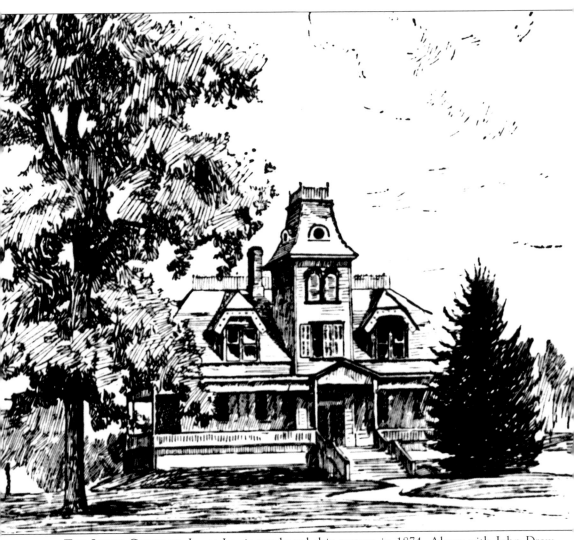

THE LEWIS COTTAGE. James Lewis purchased this cottage in 1874. Along with John Drew, Mrs. George H. Gilbert, and Ada Rehan, Lewis was one of the "Big Four" of Augustin Daly's Fifth Avenue Theater Company. The cottage still stands at 18 Beach Avenue.

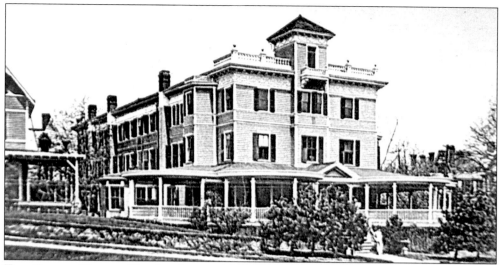

THE BEVAN HOUSE. The Larchmont Manor Company's grand development plans were stymied by the financial panics of 1873 and 1879. In this distressed state of affairs, the company put up several rental cottages and other property owners quietly—and in violation of deed restrictions—opened their homes to summer boarders. Over the next 20 years, the transient summer colony grew, the boardinghouses prospered, the attention of hoteliers was attracted, and the battle lines were drawn between the cottage owners and (as one of the cottagers put it) "persons not desired at Larchmont." The Bevan House was established in 1891 by Mary A. Bevan on the site of Rose Cottage, which had been conducted as a boardinghouse since 1881. In 1980–1981, the Bevan was restored as a single-family residence at 78 Park Avenue.

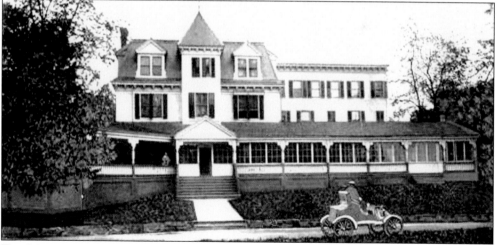

THE MITCHELL HOUSE. The Mitchell House was established by Harriet Mitchell in 1887. For almost 20 years, the premises was managed, according to court papers, "as a boarding house for the entertainment of gentlemen and their families who desired to spend the heated term in the country. The large majority of the patrons of the house were permanent guests who not only lodged and took their meals there but remained for a considerable period of time." Things changed, however, when the Mitchell House opened for the 1905 season as "a roadhouse and drinking saloon." The cottagers initiated legal proceedings, and a number of inconclusive lawsuits swiftly followed. The question was rendered mute on December 30, 1905, when the Mitchell House and all its outbuildings "mysteriously" burned to the ground.

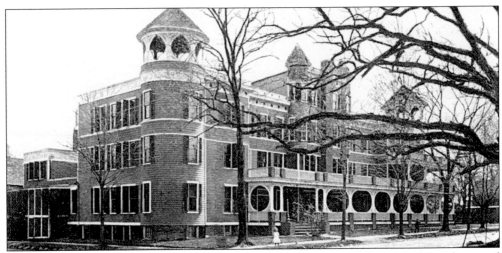

THE BELVEDERE. The Belvedere, named for its "capacious towers from which unobstructed views of Long Island Sound may be obtained," was built in the spring of 1893 for George Chatterton, recently the manager of the Dakota Apartments in New York City. Although it sometimes accommodated overflow guests from the nearby estates of the Barrymores, D.W. Griffith, and vaudeville magnates Edward Albee, John J. Murdoch, and Frederick Proctor, the Belvedere catered largely to New York City families and was known for its "wholesome, family atmosphere." Subsequently winterized and renamed the Manor Inn, the building was purchased in 1954 by John Nyberg, a nursing home operator in nearby New Rochelle, who ran it as a residential hotel for senior citizens until 2002. At the present time, its fate appears uncertain.

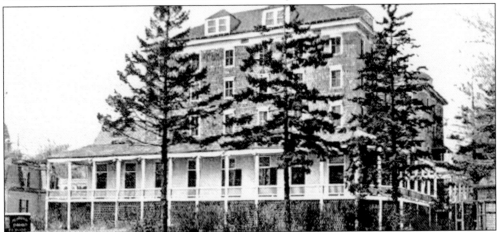

THE ROYAL VICTORIA. The Royal Victoria, the largest and grandest of Larchmont's resort hotels, was erected in 1895 by May Charman (later Mrs. William Wilcox) to provide a summer resort for the guests who patronized the two hotels she was already operating on 42nd Street in New York City. Her guests were, by all accounts, a rowdy, politically connected, and wealthy bunch. Her open barroom and public entertainments enraged the cottagers. "Such goings-on are not conducive to the good morals of the community," they deposed in one of many lawsuits. At last a compromise was struck, and the Victoria became not only the temporary abode of the likes of Blanche Ring, Douglas Fairbanks, Mary Pickford, Charles Dillingham, and Anna Pavlova but also a part of the cottagers' own social scene. It closed at the end of the 1927 season and never reopened. It was razed in 1935 and eventually replaced with three mid-century houses at 20–40 Park Avenue.

CHARLES MURRAY. When Thompson J.S. Flint died in 1882, the presidency of the Larchmont Manor Company passed to Charles H. Murray, who had long been a major partner, and Frederick Flint's childhood friend William H. Campbell was called down from Orange County to become superintendent. "From that time may be dated the prosperity of Larchmont," proclaimed the *Mamaroneck Paragraph* in a flattering tribute to "Larchmont's leading citizen" in 1894. A native of Albany, Murray began as a clerk and ended up with the store. He also "made judicious investments in real estate and stocks" and "became connected with the banking and exchange business in New York City."

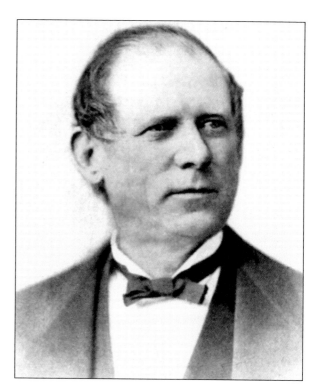

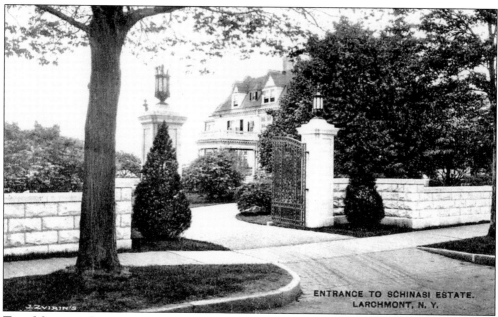

ENTRANCE TO SCHINASI ESTATE.
LARCHMONT, N. Y.

THE MURRAY ESTATE. Charles Murray built his cottage on a plot of land bounded by Larchmont, Magnolia, and Ocean Avenues c. 1888. It was sold some 20 years later to Morris Schinasi, the Turkish tobacco magnate. Schinasi added the marble walls and ornate iron gate, which are all that now remains of the estate. The view here is from approximately 9–17 Larchmont Avenue.

51

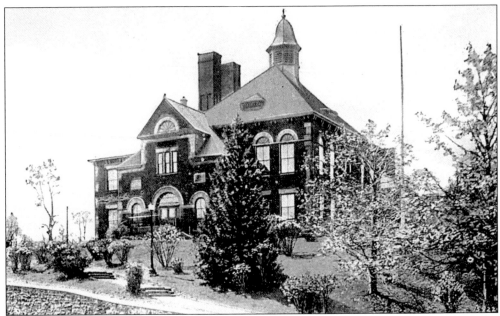

MAMARONECK FREE AND HIGH SCHOOL. Constructed in 1888 to plans by David Jardine, this building accommodated all students in grades 1 to 12 (except for a few primary pupils who remained at the Weaver Street School) until 1902, when the Chatsworth Avenue School was built for youngsters living in the Larchmont area. After 1925, when a new high school was built on Palmer Avenue, it served as the Central Elementary School. When "New Central" was built in 1965, this building became an annex for the high school, and after the erection of the Hommocks Middle School in 1968, it was converted to administrative offices for the school district. Since 1982, it has served as the Mamaroneck Town Center, housing administrative offices, the courthouse, and police headquarters.

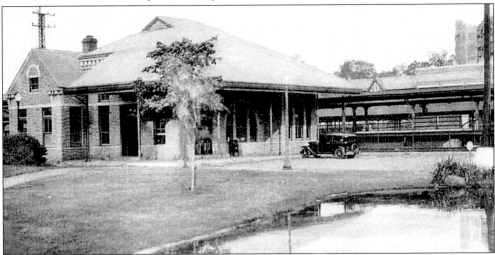

THE NEW YORK–NEW HAVEN STATION. In 1887, the New York and New Haven Railroad completed a four-track line, which served as a spur to local development. This granite station with elaborate interior fittings was constructed in 1888 as a model for other stations along the line. It was destroyed in 1954 to make way for the New England Thruway. Only the pond remains today.

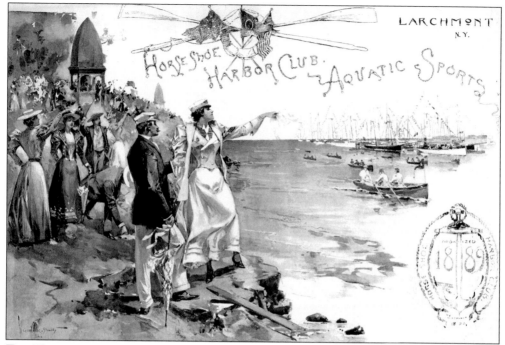

THE HORSESHOE HARBOR CLUB. The Horseshoe Harbor Club (later the Horseshoe Harbor Yacht Club) was organized in 1889. Its clubhouse was a small building that, since its erection *c.* 1850 by Edward Knight Collins, had served as workshop, boathouse, bathhouse, community center, house of worship, and the first home of the Larchmont Yacht Club.

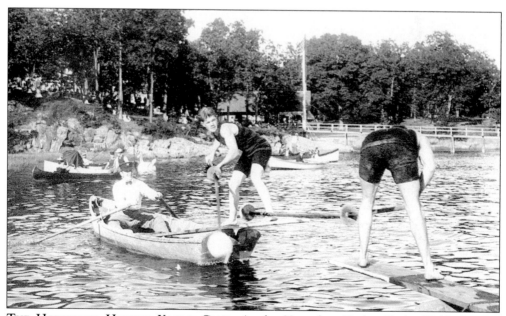

THE HORSESHOE HARBOR YACHT CLUB. At the Horseshoe Harbor Yacht Club's Aquatic Sports of 1900, two young knights joust from planks cantilevered off rowboats.

53

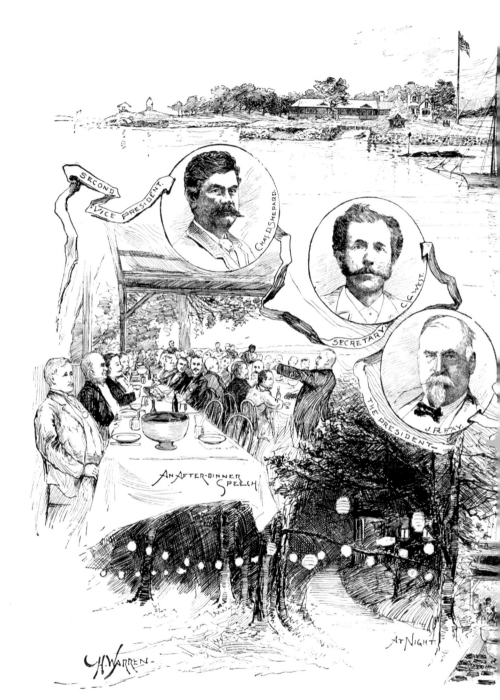

SECOND VICE PRESIDENT.
CHAS. D. SHEPARD.

SECRETARY C. C. WEST.

THE PRESIDENT. J. R. FAY.

AN AFTER-DINNER SPEECH.

AT NIGHT.

H. WARREN.

OPENING DAY OF THE HOBOKEN TURTLE CLUB'S

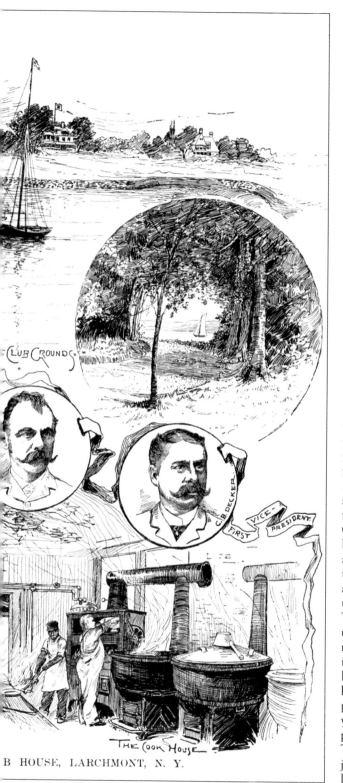

CLUB GROUNDS

C. B. DECKER. FIRST VICE-PRESIDENT.

THE COOK HOUSE

B HOUSE, LARCHMONT, N. Y.

THE HOBOKEN TURTLE CLUB.
Founded in Hoboken, New Jersey, in 1796, the Hoboken Turtle Club was originally an organization of wealthy and socially prominent men who met twice a year to feast on turtle steaks. The club is known as an example of the social and fraternal groups that flourished after the Revolution. George Washington is said to have been a member, and Aaron Burr and Alexander Hamilton are said to have fought their famous duel after attending a club outing in the Elysian Fields of Hoboken. The club met in various places until 1890, when one of the members, Charles D. Shepard, sold it a four-acre tract of waterfront land in Larchmont Manor. Three handsome buildings and a large pavilion were erected; by the next year, the club was bankrupt and the property went into receivership. The Turtles' motto was "As we journey through life, let us live a little by the way."

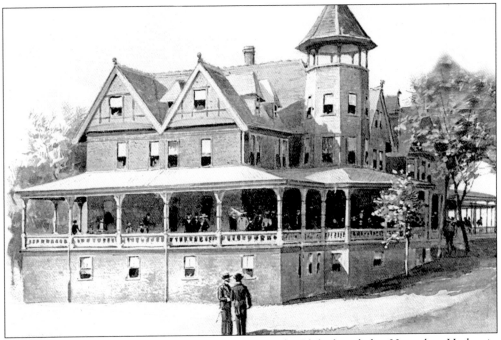

THE LARCHMONT YACHT CLUB. The Larchmont Yacht Club, founded at Horseshoe Harbor in 1880, drew attention to the Manor Company's largely failed development project and resulted in the sale of a large number of lots by the end of the decade. In 1886, the club purchased and began enlarging the waterfront villa, seen here, which was originally the summer home of Benjamin Carver, a railroad executive.

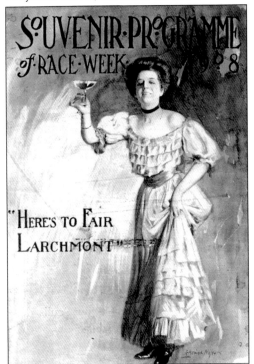

THE LARCHMONT YACHT CLUB RACE WEEK. By the time the club moved into the Carver villa, it had acquired fame and status all along the East Coast. Although the members of truly awesome means both lived and summered elsewhere—Caldwell Colt of Colt Firearms; H.M. Flagler, builder of the Florida East Coast Railway; C. Oliver Iselin of America's Cup fame; and in the 1890s, August Belmont, Andrew Carnegie, J.P. Morgan, and William K. Vanderbilt—their association made the club's annual Race Week an international event. The cover of the 1908 "Programme," shown here, was designed by a former hall boy at the club, G. Patrick Nelson, whose artistic talent was noted by club members who underwrote his education at the Art Students League and afterward at the Academie Julien in Paris.

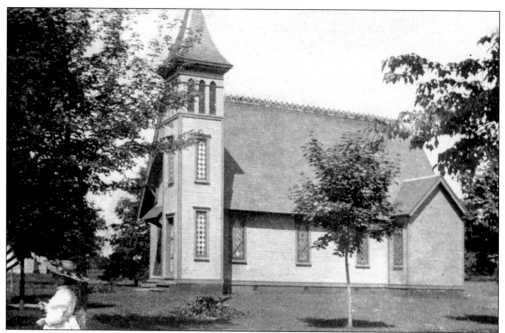

ALL SAINTS CHAPEL, JULY 1894. "Wild and gay were the young clubmen; their melodies flooded the midnight air; their genial and generous thirst set the staider and older cottagers to thinking, and so they founded as an ameliorative the pretty little chapel in the centre of the property," the *Paragraph* recalled in 1892. The reference is to All Saints Chapel, erected by the Manor Company in 1882 on Linden Avenue at the corner of Prospect Avenue as a setting for the union services displaced from Horseshoe Harbor by the Larchmont Yacht Club. The Episcopalians supplied the minister.

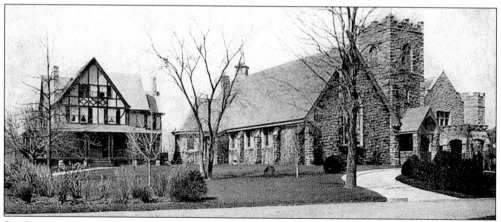

ST. JOHN'S EPISCOPAL CHURCH. "Hardly had the first church been completed before it became too small and plans took shape to build a larger and more dignified one," St. John's historian relates. "The little group of women who had mothered the Church since its birth in the Horseshoe Harbor Club added new members and redoubled their efforts. Through lawn parties and fairs they started a building fund." Charles Murray, president of the Manor Company, made an especially heavy contribution, the congregation became St. John's Incorporated Parish in 1891, and the new church was erected near the site of All Saints Chapel in 1894–1895 to plans by Walter C. Hunting.

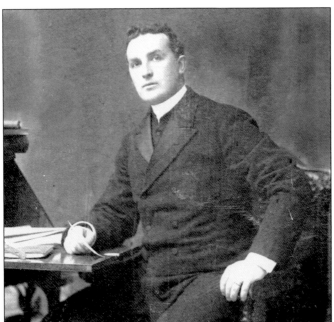

DR. RICHARD COBDEN.
The first rector of St. John's was Dr. Richard Cobden, formerly the minister of St. Mark's Episcopal Church in Manhattan. He was asked to serve as chaplain of the Larchmont Yacht Club, beginning a tradition of long standing. He lived at 56 Prospect Avenue.

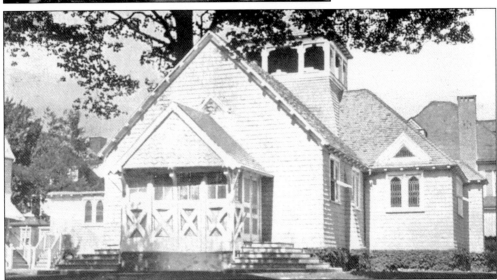

ST. AUGUSTINE'S CATHOLIC CHURCH. "The spiritual needs of the few Catholics who lived in the vicinity were the charge of the priests in New Rochelle and Mamaroneck," the St. Augustine's Church historian writes. That was a long buggy ride. The Manor Company had offered to donate a site for a Catholic church, and in 1891, when the Company dissolved, "the members of the original Manor Company, only one or two of whom were Catholics, made good their original offer, and enabled their Catholic fellow-townsmen to erect their own place of worship. Most of the funds for the construction of this little church were raised by members of the Episcopal congregation," along with Augustine Adams, a resident of 15 Woodbine Avenue and the wife of English investor Oliver Adams. The list of donors carried the names of almost all the early residents of Larchmont Manor. The church, dedicated in 1892, was erected at the corner of Beach and Linden Avenues where, much remodeled, it today serves as a private residence. The first pastor of St. Augustine's was the Reverend Edmond J. Power.

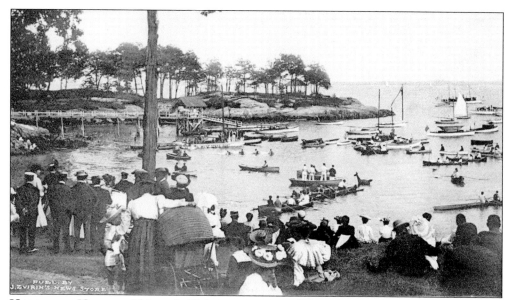

HORSESHOE HARBOR. This early-20th-century view of Horseshoe Harbor, probably depicting the annual Water Sports, has enough in it to repay an hour of study—from the disgruntled-looking woman in the flowered hat in the center foreground, to the woman with one hand resting protectively on a wicker baby carriage while comforting a small boy with the other hand, to the men in their sailor hats, the scullers, the inflatable toys in the water, and beyond.

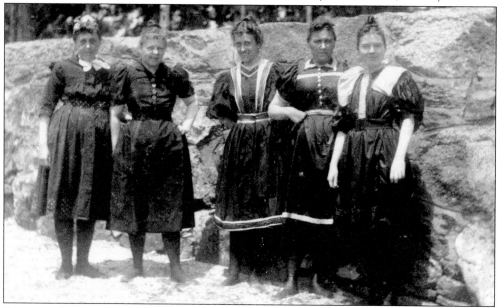

BATHING BEAUTIES OF 1895. These women at Manor Beach show off the season's latest styles, which included long stockings, rubber-soled high-topped boots, voluminous sleeves, and petticoats. When the Victorians talked of "bathing," they meant it—a dip in the water, and not a swim, was all these heavy costumes allowed. From left to right are Lucy Mariah White, whose summer home was at 46 Magnolia Avenue; "Auntie" West (wife of Isaac H. West), a neighbor and close friend of the family; Mabel White Freeman, daughter of Mrs. White; and others unidentified.

CHILDREN ON THE BEACH. The Kirtland children and their nanny pose on Manor Beach. The *c.* 1883 house in the background belonged to Joseph Bird, president of the Manhattan Savings Bank, a founding trustee of the Larchmont Manor Park Society and first treasurer of the village of Larchmont. It was torn down in the 1940s.

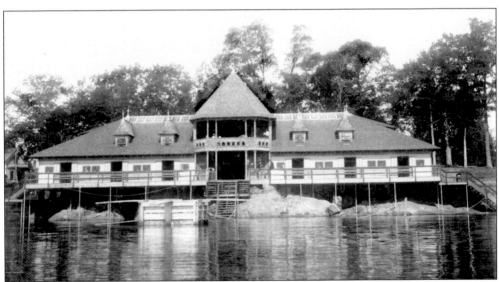

THE BATHING PAVILION. Early in 1891, the Larchmont Manor Company, having sold most of its lots, announced its intention to dissolve. A committee of homeowners met and determined to form the Larchmont Manor Park Society to take ownership of the common lands and manage them on behalf of property owners in Map 610. The society turned its attention first to "the necessity for suitable bathing facilities, the old bath houses having been torn down and removed" and the sea wall having washed away. Expenses for the new pavilion and sea wall came to $7,615.50, of which $5,000 was raised by subscription. David Jardine supplied the plans, and William Campbell supplied the laborers.

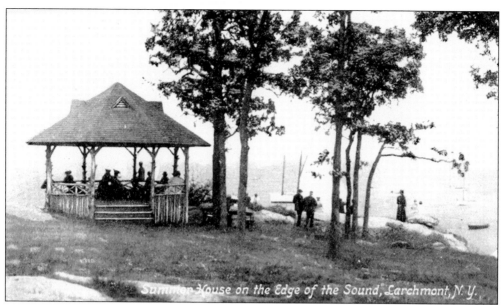

Summer House on the Edge of the Sound, Larchmont, N.Y.

A SUMMERHOUSE. The 1873 pagodas on the east and west points of Manor Park had succumbed to the weather by 1896, when they were replaced with little temples "in the Greek style." These proved even less substantial, and they were replaced in 1902 by "rustic summer houses" with posts of undressed tree trunks, as seen here. These, too, went the way of all things and were replaced in 1933–1934 by the existing summerhouses, which resemble them in shape but are more sturdily built.

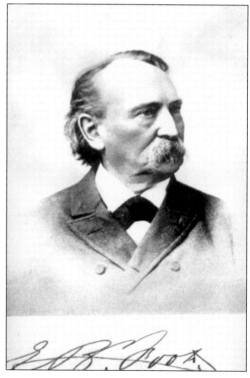

DR. EDWARD BLISS FOOTE. Born in Ohio in 1829, Edward Bliss Foote was a heavy investor in Larchmont real estate and a colorful character whose least distinction was that of being the grandfather of dancer Irene Castle. Foote had a long and successful career as a printer and newspaper editor before beginning the study of medicine. Graduating from Pennsylvania Medical University in 1860, he moved to New York and developed a medical practice described by his biographer as "world-wide and lucrative." Combining his two vocations, he published many books, periodicals, and monographs for a popular audience. He was an early proponent of the use of electricity to ameliorate many conditions, and his vigorous promotion of sex education and birth control caused much controversy, as did his assertion that the brains of "criminals, idiots, and imbeciles" could be much improved by reconstruction "under the manipulations of skillful surgeons."

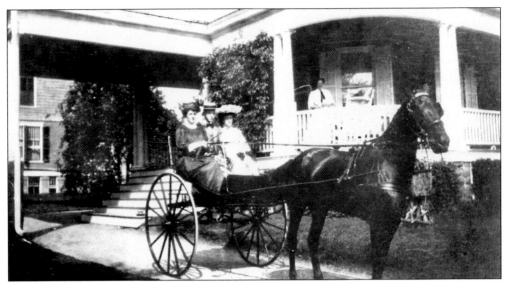

THE GEORGE TOWLE COTTAGE. A matron watches from the veranda of 17 Linden Avenue as two young women in fanciful hats, flanking an apparently younger man in a straw bowler, prepare for a drive in a smart two-wheeled buggy drawn by a handsome horse. The house was built in 1895 by George Sibell Towle for his bride, Florence Hubbard. Towle's father, Frank Towle, served as engineer for the Manor Company and was responsible for Map 610 and the laying out of Manor Park. Florence Hubbard's parents were also Larchmont Manor pioneers. George Towle was a long-time Larchmont fire chief and died in this house in 1936.

THE DAVIDSON COTTAGE. The house at 6 Linden Avenue is one of two on the Davidson estate on the 1892 map. William Davidson, a New York City coal dealer, is sometimes mentioned as an early partner in the Larchmont Manor Company. In 1917, the house was owned by Joseph Gleason, president of Montgomery and Company, dealers in railroad supplies and hardware, and of the Mamaroneck Board of Education. The owner referred to on this *c.* 1925 postcard was Martin Cassidy, about whom nothing is known.

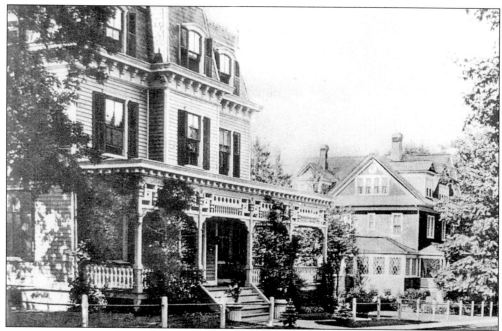

THE HAIGH AND DOWDNEY COTTAGES. Huntley Haigh, a New York City builder, purchased this lot at 6 Helena Avenue from the Larchmont Manor Company in 1872 and built the house soon after. It remained the summer home of the Haigh family for more than 50 years. The house next door (right) was the summer home of Congressman Abraham Dowdney, an Irish immigrant who served in the Civil War, married well, invested in real estate, and became wealthy. Dowdney's house, like several others in the Manor, fell victim to the Depression and has been replaced by a mid-20th-century dwelling at 2 Helena.

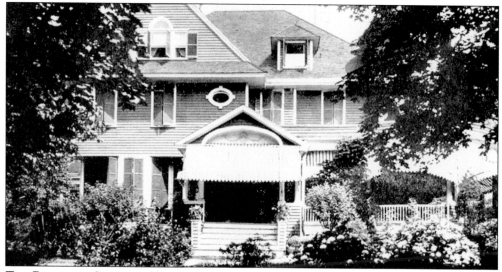

THE ROWLAND COTTAGE. New York City architect Frank A. Rooke designed this retirement cottage at 22 Chestnut Avenue for Thomas Fitch Rowland, president of the Continental Iron Works in Brooklyn. Rowland was famed as the builder of the ironclad USS *Monitor* (1862), designed by naval architect John Ericsson, which brought an end to the age of the wooden warship. After Rowland died, his son Thomas Fitch Rowland Jr. made his home here.

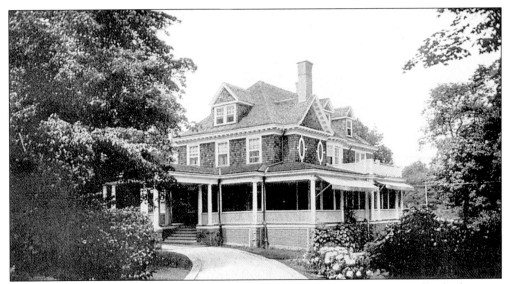

THE SHRIVER COTTAGE. This elegant site at 8 Woodbine Avenue was originally the location of the Larchmont Manor Company's stables. The house, designed by a Mr. Stone, was built in 1896 for H.T. Shriver. It was later the home of Dr. James F. Hasbrouck, a professor of oral surgery at New York University College of Dentistry. From c. 1910 until his death, Hasbrouck served as a trustee of the village and of the Larchmont Savings and Loan, as a director of the Larchmont National Bank and Trust, and as a vestryman at St. John's Episcopal Church.

THE KIRTLAND COTTAGE. In the fall of 1898, William G. and Anna Field Kirtland of New Rochelle moved into a new year-round cottage at 30 Chestnut Avenue. They and their descendants remained there for several decades.

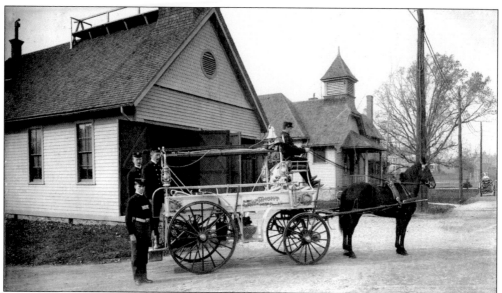

THE FIRE DEPARTMENT. For 13 years following its incorporation in 1891, the village of Larchmont was ruled by "a board of village fathers, selected by the Larchmont Yacht Club, who intimidated the proletariat by wearing evening clothes and crush hats to board meetings," according to a 1904 article in the *New York Sun*. These "Joy Clothes" were the issue in the making of the reputation of Larchmont's "millionaires' fire department" (which was founded in 1890, preincorporation, as an organization of volunteer cottagers who financed their own equipment). This reputation began one Saturday night in 1893, when the firemen turned out from the Larchmont Yacht Club and local resort hotels "in full dress suits" to fight a fire. The *New York Herald* reported that the department "is probably the wealthiest volunteer fire department on the face of the globe" and claimed, falsely, that all 105 active volunteers were also members of the Larchmont Yacht Club. To the right of the firehouse stands Larchmont Village Hall, originally built by the Manor Company as a school but never used for that purpose. The buildings stood near the corner of Maple and Circle Avenues until razed in 1926.

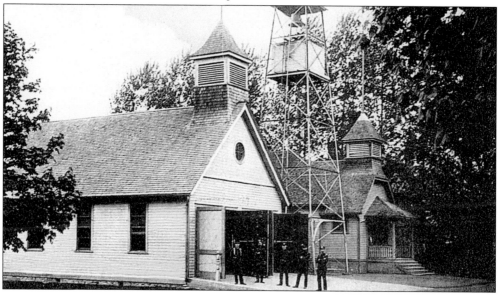

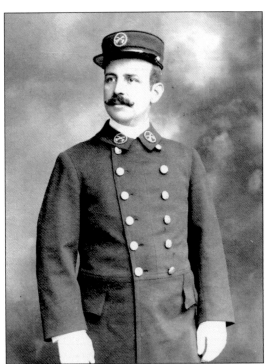

MAYHEW WAINWRIGHT BRONSON.
Certainly the volunteer fire department was as much a social club as a firefighting organization, and certainly the tone was set in the early years by the "dudes." The biggest dude in the department's history, from its beginnings until his death in 1936, was Mayhew Bronson. A bachelor of independent means, Bronson devoted his life to community and philanthropic causes, and he served as chief of the fire department from 1900 to 1904. Two local streets are named after him, as well as a rock in Flint Park, which he was instrumental in organizing out of five acres of swampy land donated to the village in 1915 by Helena Flint.

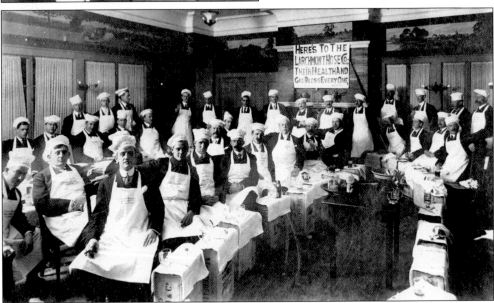

A FIRE DEPARTMENT PARTY. The entire fire department was a convivial lot, but the Larchmont Hose Company (reportedly manned mostly by members of the Horseshoe Harbor Yacht Club) left more records of its festivities than did the Larchmont Hook and Ladder Company (heavily endowed with Larchmont Yacht Club members) or the Larchmont Engine Company (headed by William Campbell, superintendent of the Larchmont Manor Company and manned by largely blue-collar chaps). One of the hose company's rituals was a midwinter Entertainment and Chowder, and that may be what is going on in this photograph. "Here's to the Larchmont Hose Co., Their Health, and God Bless Everyone," the banner proclaims.

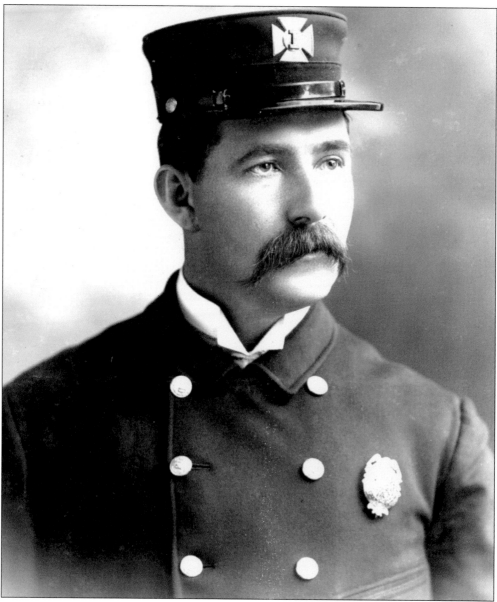

JOHN HICKEY. Shown here in his fire department uniform, John Hickey came from County Limerick in Ireland in 1892 to join his sister in Larchmont and soon became a local institution. He managed the horsecar barn and often drove the cars, along with Owen Sweeney and William Brennan. After the horsecars were replaced by electric trolleys in 1899, Hickey stayed on as motorman. He was elected village tax collector in 1905 and town highway commissioner in 1907. The head of Hickey's fire department company was William Campbell, superintendent of the Larchmont Manor Company. Campbell was described in his 1906 *New York Times* obituary as "the father of Larchmont." According to an early Larchmont historian, "Before its incorporation the village was in the hands of one person, Superintendent Campbell, who acted as constable, fire warden, postmaster, and directed all other necessary services." Another eye witness recalled that "Campbell was the local boss. If one wanted anything from coal or wood to real estate, you had to consult Campbell. He usually delivered the goods."

ye OLde Larchmont Fire

A FIRE DEPARTMENT CARTOON. Herb Roth was a cartoonist and illustrator for the *New York World* who was a well-known resident of Larchmont in the 1930s and 1940s. His linocut for the Golden Jubilee celebration of the fire department reveals that he made a close study of local history before he sat down at his drawing board. Included are William Camp, who once rang the

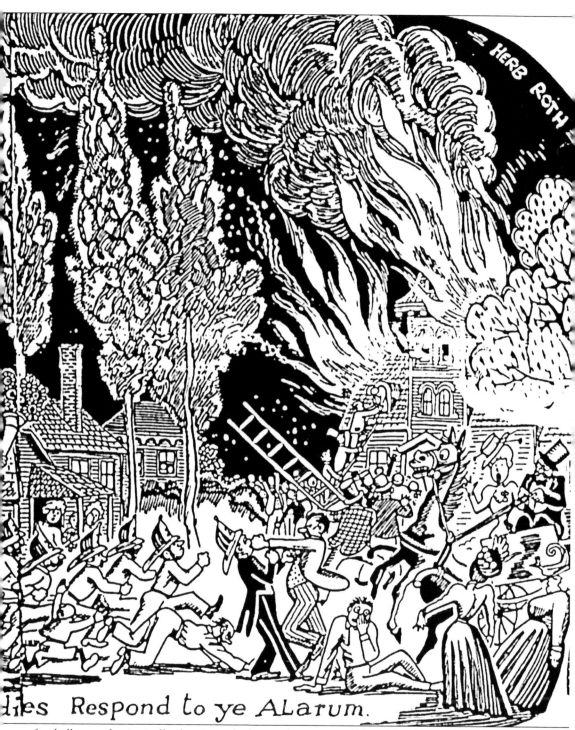

lies Respond to ye Alarum.

fire bell so enthusiastically that it cracked; irate homeowner Edward Tooker, whose brand-new mansion directly across the street from the firehouse is going up in flames; the police chief, dressed in evening clothes and a fire helmet, getting punched in the nose by Tooker; and a good likeness of Mayhew Bronson, posing atop the hose cart, holding a fire trumpet filled with posies.

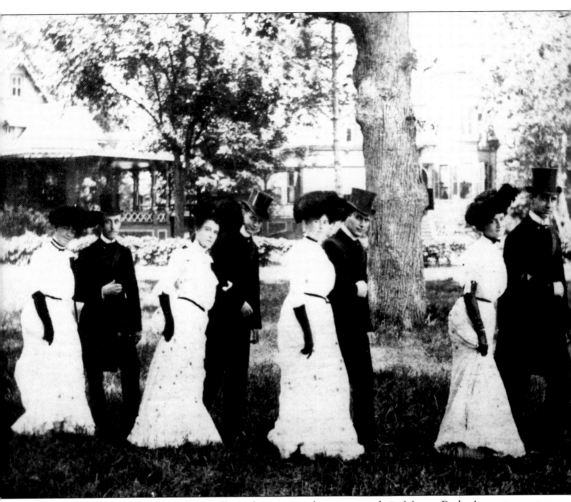

A WEDDING PARTY, C. 1890. Four elegant couples promenade in Manor Park. A contemporary notice names the men, from left to right, as Charles Perrin, Louis Spencer, Harold Hayward, and Thompson S. Flint—all sons of prominent Larchmont Manor residents—and says that "the ladies cannot be identified." Another source reports an entertainment that consisted, in part, of four young men dressed as women accompanied by escorts. Such mock wedding parties seem to have been a common amusement of the era.

GEORGE WIGHT. Early in 1891, the Larchmont Manor Company, having sold most of its lots, announced its intention to dissolve and asserted that it would rather turn its streets over to a village form of government than to the town of Mamaroneck. George Wight, president of the Lorillard Refrigerator Company and a summer resident since 1888, invited all Larchmont Manor property owners to meet at his home to discuss this proposal. The reaction was favorable. State law required that a village have at least 300 inhabitants to a square mile; it was therefore decided that the boundaries would be set to enclose, in addition to the 288 acres of Larchmont Manor, sufficient territory to take in exactly one square mile. After all due formalities were observed, the village of Larchmont was incorporated on September 2, and Wight was subsequently elected president (an office later changed to mayor).

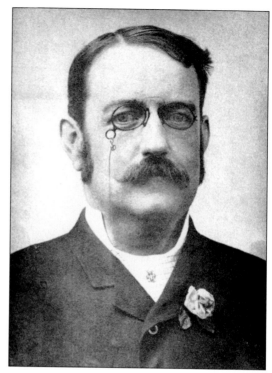

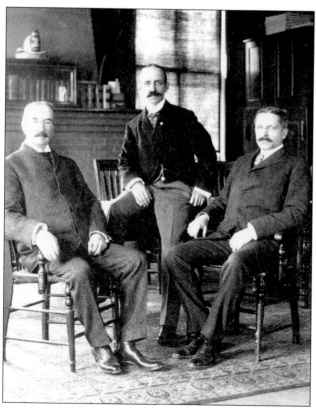

THE VILLAGE BOARD. When the inaugural board of trustees met on September 26, 1891, there was little to distinguish the meeting from gatherings at which public affairs had been arranged in preincorporation days. William Campbell, trustee, had served since 1885 as the chief operating officer of the Manor Company and was a major partner in the Larchmont Manor Horse Railway Company. George Wight, president, was a major partner in the privately held Larchmont Water Company. Marmaduke Tilden, village clerk, was resident manager of the Larchmont Yacht Club. Ambrose Montross, tax collector, was a liveryman who had long been employed by the Manor Company. From left to right are 1905 village board members John R. Hall, Mayhew Bronson, and Eustis L. Hopkins.

71

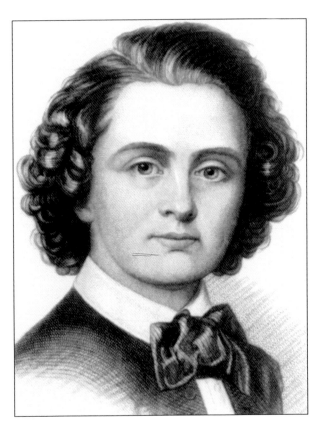

HARRIET HOSMER. In 1894, Helena Flint made the grand tour of Europe and returned to Larchmont with a monumental fountain in the shape of a bronze mermaid piping a lullaby to her infant. This she gave to the new village of Larchmont as a memorial to her father. *The Mermaid's Cradle* was the work of Harriet Hosmer (shown here), an American sculptor working in Rome. The darling of European literati and minor nobility, she was renowned in the mid-19th century for her neo-Classical marbles.

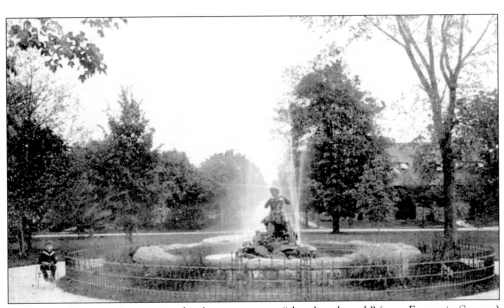

FOUNTAIN SQUARE. As a setting for the monument, "the church park" (now Fountain Square) was redesigned by Walter Hunting, a Larchmont architect whose design for the adjacent St. John's Episcopal Church was then under construction.

Three

TWO LARCHMONT FAMILIES

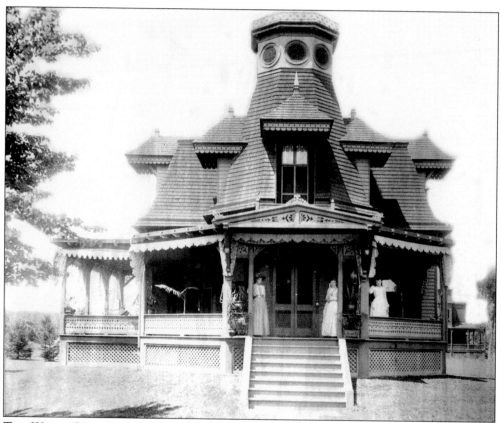

THE WHITE COTTAGE, C. 1891. Elbridge Hallam White, a New York City textile importer, purchased one of the Manor Company's rental cottages, 46 Magnolia Avenue, in 1891. The house remained in the same family until 1996, through four generations. The last Larchmont member of the family, June Freeman Allen, moved away in 2002.

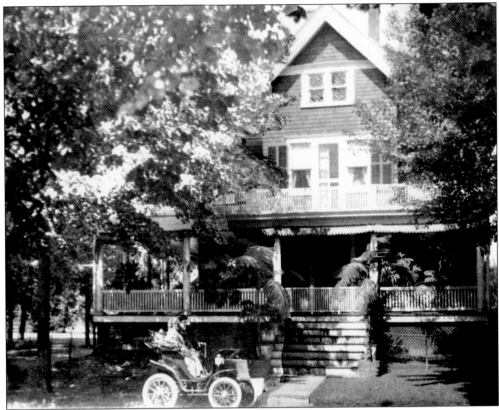

THE WHITE COTTAGE, C. 1900. June Allen, wife of Bruce Allen, recalled that her grandfather Elbridge White referred to this house as "a chicken coop" and remodeled it into a far more substantial dwelling. Shown are White and his wife, Lucy Mariah, in their electric automobile—one of the first in Larchmont—in front of their renovated summer home.

THE NEW FRONT PORCH. The Whites' new porch sports mature palm trees that were boarded during the winter months at Grant's Florist on Weaver Street.

THE NEW ENTRY AND PARLOR. The furnishings remained largely unchanged through the subsequent residencies of the Whites' daughter Mabel and her husband, Clarence Randolph Freeman, and that of their daughter June and her husband, Bruce Allen.

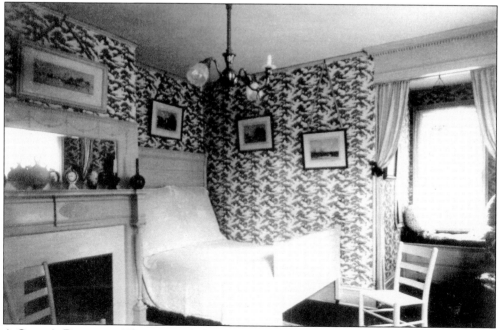

A CHILD'S BEDROOM. This was Mabel White's room when she was a child. Years later, as Mrs. Clarence Freeman, she gave birth to her daughter June in this bed.

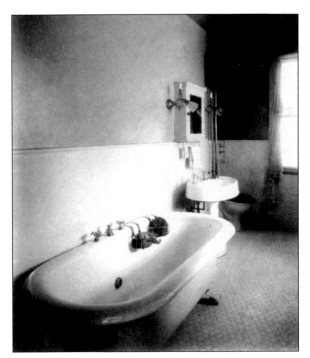

THE NEW BATHROOM. Running water had been brought to Larchmont Manor by Charles Murray's Larchmont Water Company in 1889. In 1894, Murray founded the Larchmont Electric Company, with its generator in Mamaroneck opposite the freight depot. Larchmont Village ordered 100 lights of 25 candlepower each, and 35 homeowners contracted to have electricity introduced into their houses. The lights went on for the first time on September 22, 1894. Henceforth, there were fewer thrilling scenes of flaming kerosene lamps being hurled out of windows. However, the new "daylight in a jar" was not totally reliable; notice the candleholders atop the electric sconces beside the bathroom cabinet.

ELBRIDGE HALLAM WHITE. Posing for a formal portrait in his later years is Elbridge Hallam White.

EXPERIENCE DeGROOT FREEMAN.
Experience DeGroot married Alpheus
Freeman, and they became the parents of
Clarence Freeman.

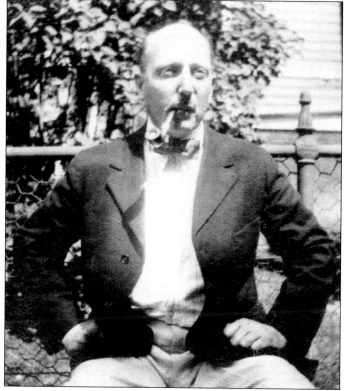

**CLARENCE RANDOLPH
FREEMAN.** Clarence
Freeman married Mabel
White, and they became
the second generation
to occupy 46 Magnolia
Avenue. Their daughters,
Claire and June, grew up
here and at the Freemans'
winter home on the West
Side of Manhattan.

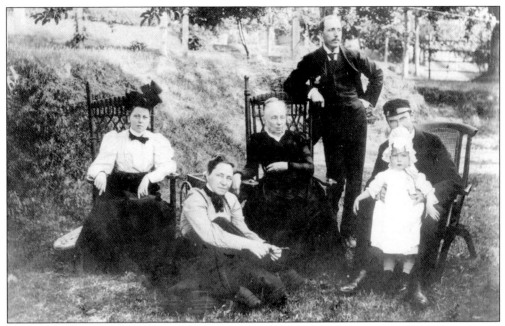

A FAMILY GROUP. The house at 46 Magnolia Avenue was a gathering place for all branches of the family. From left to right are Carrie Freeman Tiemer (wife of Paul Tiemer), Alice Freeman, "Grandmother" (Experience DeGroot) Freeman, Clarence Freeman, and Paul Tiemer and his daughter Gertrude.

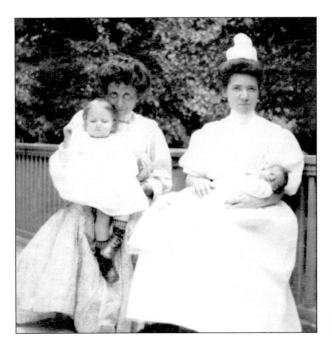

A HAPPY YOUNG MOTHER, 1909. Mabel Freeman holds her elder daughter, Claire, while the baby nurse holds newborn June.

LUCY WHITE IN HER GARDEN WITH PEKES. Lucy Mariah Sutlief White (wife of Elbridge H. White) was a skilled botanist, as were her daughter and granddaughter who succeeded her as mistresses of the homestead. The garden contained many specimen plantings from the Bronx Botanical Gardens and was lovingly cultivated for 105 years. The family also loved animals and was never without at least two dogs and a parrot.

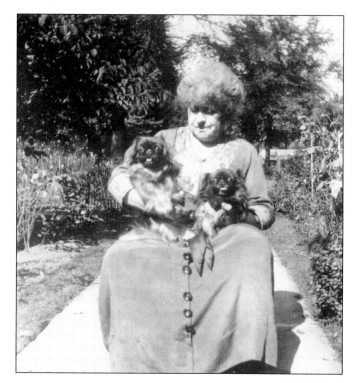

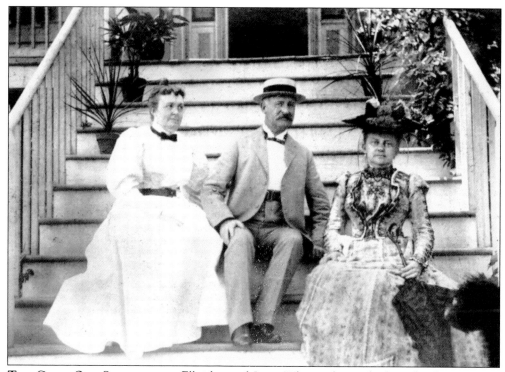

THE GOOD OLD SUMMERTIME. Elbridge and Lucy White relax with their daughter Rosetta Miriam on their porch steps. Yes, this was the cottagers' attire at their most unbuttoned.

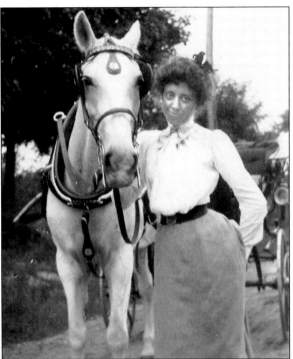

MABEL WHITE FREEMAN WITH DICK. The White-Freeman family kept a smart rig for use at their summer home. Carriage driving was a favorite pastime of the cottagers until 1900, when trolley rails were laid on the Post Road. Dick responded to an invitation to go for a drive or to return home by raising and lowering his ears.

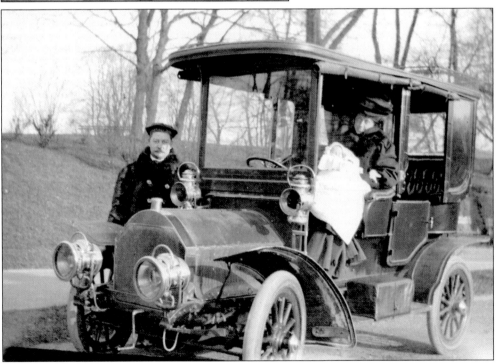

A WINTER RIDE. The family always kept an up-to-date automobile as well; seen here is a Stevens Duryea. Mabel White Freeman and baby Claire, bundled up against the cold, are being taken for a drive by their chauffeur, Alan Watrous. In later years, Mabel Freeman took a course in automobile mechanics so she could keep the family automobile running on her own.

WINTERING IN MANHATTAN. Claire and June Freeman are seen in front of their Manhattan town house. Like most of the cottagers, members of the White-Freeman family made their permanent home in the city.

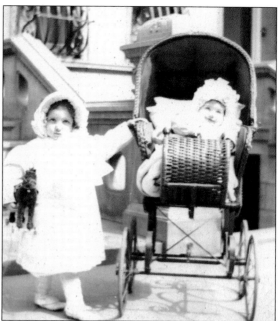

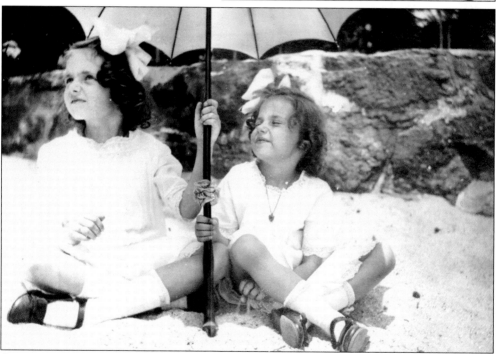

CLAIRE AND JUNE FREEMAN AT MANOR BEACH. Claire Freeman grew up to be a weaver and noted textile expert and made her home in Scarsdale. June Freeman studied botany and art history at Barnard College and married Bruce Allen, a Larchmont neighbor. They reared their four children at 46 Magnolia Avenue. She has been an energetic volunteer for many Larchmont causes and served as the second president of the Larchmont Historical Society. Her husband, a cancer research biologist, served the society as volunteer archivist for 10 years and was especially devoted to the history and preservation of Manor Park.

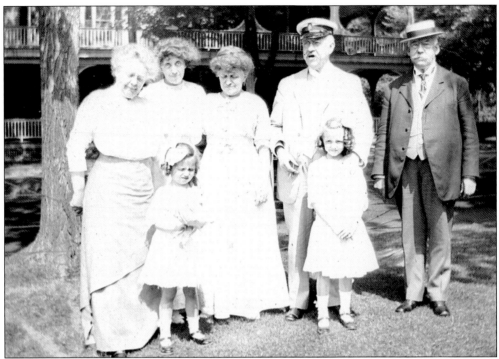

A Summer Stroll. "Auntie" West (wife of Isaac H. West), Mabel Freeman, Lucy White, Elbridge H. White, and Capt. Isaac H. West, along with June and Claire Freeman, take a break in their daily constitutional in front of the Belvedere Hotel.

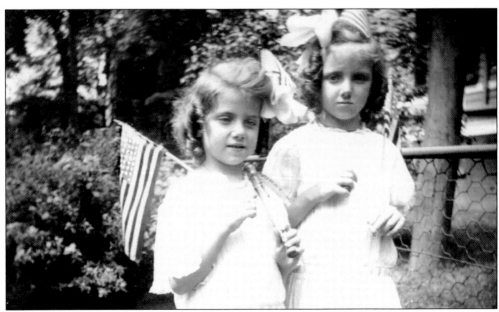

It's a Grand Old Flag. June and Claire Freeman prepare to join the Fourth of July parade through Larchmont Manor.

THE FORDYCE COTTAGE, 1894.
The Fordyce Photo Collection was purchased by the Larchmont Historical Society in 2000 from a collector in Virginia who knew nothing of its provenance. It consists of approximately 400 photographs taken in Larchmont c. 1892 to c.1911. Photograph developers' envelopes named the customer as Mrs. John A. Fordyce, permitting the identification of the source of the collection. Dr. John Addison Fordyce (b. 1858) was a noted dermatologist and specialist in the study of syphilis, listed in *Marquis' Who's Who* from 1901, until just before his death in 1925. His family made 20 Maple Avenue their summer home during precisely the period covered by the collection.

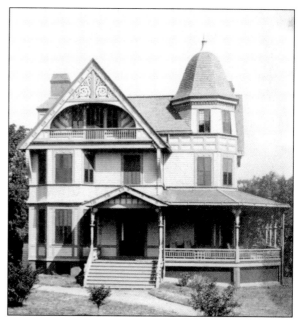

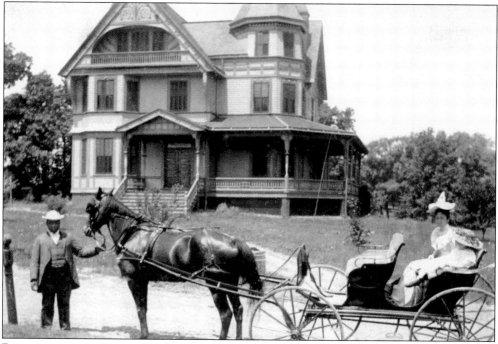

PREPARING FOR A DRIVE. The house at 20 Maple Avenue appears in both interior and exterior views dozens of times in the Fordyce Photo Collection. Dr. John Fordyce, wife Alice Dean Smith, daughter Emma (b. 1887), and son Addison (b. 1895) are photographed on the porch, in the carriage, in the garden, receiving ice from the Goodliffe delivery truck, at dinner in the dining room, and visiting the neighbors. An unusual feature of the collection is that the Fordyces photographed their servants as well, and the 1900 U.S. census provides their names and responsibilities. Here, coachman George Dorsey, who was born in Virginia, prepares to take Alice and Emma Fordyce for a drive.

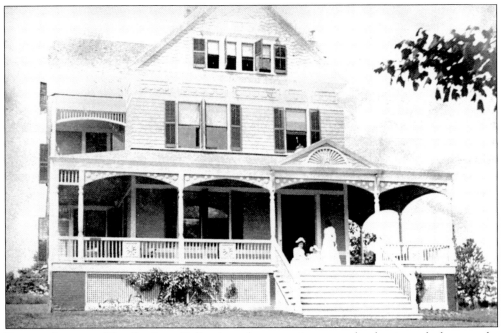

BEACH AVENUE. The Fordyce Collection also contains a good selection of photographs of adjacent 38 Beach Avenue, suggesting that relatives or close friends of the Fordyces resided there.

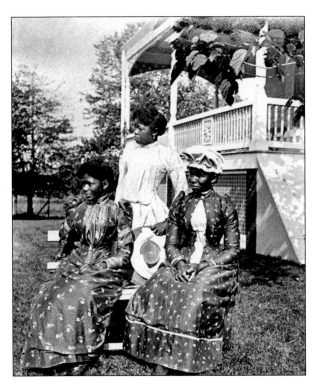

FAMILY RETAINERS. Three serving women in their Sunday best pose in the side yard of 38 Beach Avenue. If they are employees of the Fordyce family, they are Lucy Dorsey, laundress; Mary Brooks, nurse; and Margaret Wilson, cook—not necessarily in that order. All three were born in Maryland, a vital statistic that distinguishes them from other servants in Larchmont Manor, who were mostly immigrants and mostly born in Ireland.

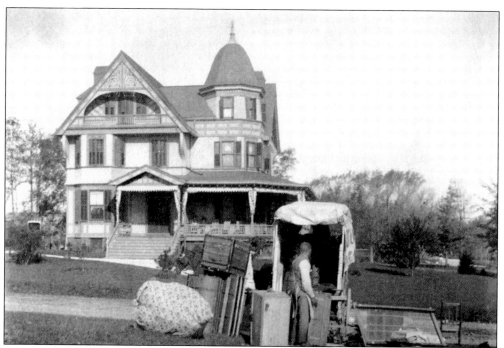

MOVING DAY, OCTOBER 1894. With 20 Maple Avenue in the background, the residents of 38 Beach Avenue are packing up to return to the city. As their summer homes were without heat, save what could be extracted from a fireplace or two, the cottagers typically arrived in May and departed in mid-October. It appears that the trunks are being loaded into a horse-drawn wagon, which would most likely cart them to the railroad station for the trip to the city.

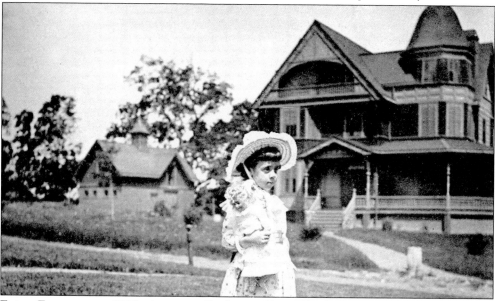

EMMA FORDYCE, C. 1892. An unusually demure Emma Fordyce stands in front of 20 Maple Avenue, with the carriage house (later remodeled beyond recognition into a private home that still stands at 24 Maple Avenue) at the left. In other views, she appears to be a mischievous child, crossing her eyes or sticking her tongue out at the camera.

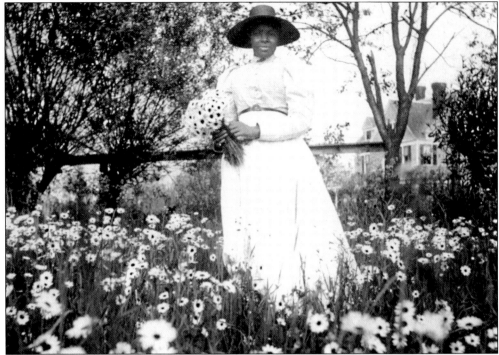

A WOMAN IN A FIELD OF DAISIES, JUNE 18, 1893. This photograph was taken in the large side yard of 20 Maple Avenue. Golf course–like lawns were not much esteemed in those days. This might be the Fordyces' nurse, Mary Brooks. The photographer of this and most other views in the collection was probably Dr. Fordyce, who practiced photography not only as a hobby but also as physician, shooting and arranging one of the most comprehensive collections of pictures of dermatological diseases in existence, according to the *Dictionary of American Biography*.

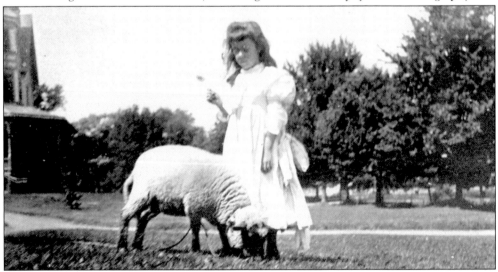

MOWING THE GRASS. Emma Fordyce's sheep was not only a pet but also a lawn mower. Hired men swinging scythes cut down the tall weeds in May; the family sheep kept the front yard tidy for the rest of the summer. A few of the cottagers, such as Dr. Edward Bliss Foote, used cows instead.

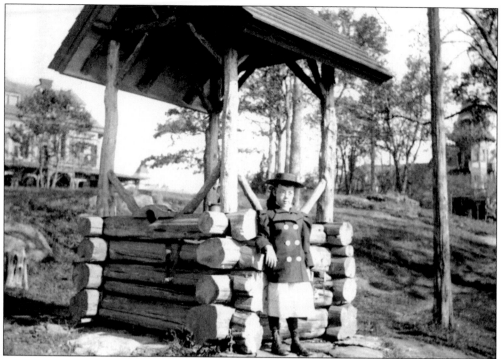

EMMA FORDYCE AT THE WELL, OCTOBER 1893. Emma Fordyce at age six poses by the well in Manor Park. By this time, wells in Larchmont Manor were more picturesque than functional, water mains having been laid to the area from Sheldrake Lake up Weaver Street in 1889.

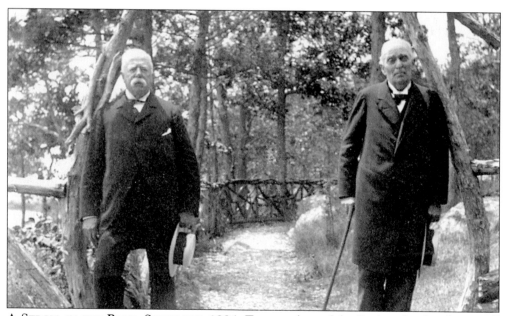

A STROLL IN THE PARK, SEPTEMBER 1894. Two members of the Fordyce family take a stroll in Manor Park. Note the rustic railings and arbor.

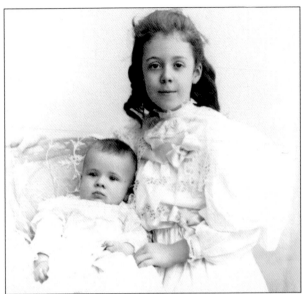

EMMA AND ADDISON FORDYCE, APRIL 1895. Studio photographs are rare in the Fordyce Photo Collection. This one shows Addison at four months and Emma at eight years of age.

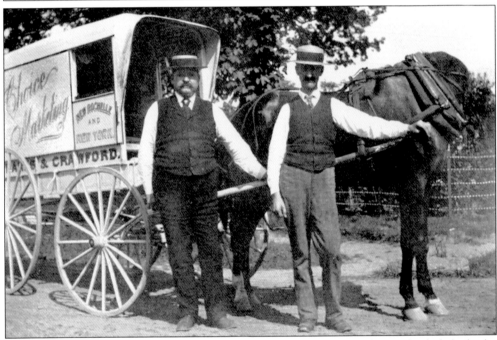

DELIVERING THE GROCERIES. A covenant in Larchmont Manor Company deeds forbade the erection of "any slaughterhouse, smithshop, forge, brewery, circus, barroom, store," and on through a 90-word list, ending with—just to make sure everybody got the point—"any business purposes whatsoever." In the 1870s, the cottagers' needs had been supplied from New York City, according to an eyewitness: "Once a week a representative from Albro's wholesale grocery in New York City paid a visit to the little towns along the Sound to gather in the order for supplies of food for the following week." By 1892, realtors were advertising that "butchers, grocers and supply men of all kinds, both at Mamaroneck and New Rochelle, call twice a day at the door of each house, winter and summer, and provide all living commodities at low rates." Supplying the Fordyces' needs was Choice Marketing of New Rochelle and New York.

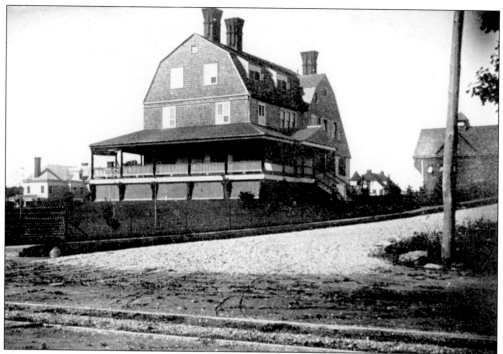

THE ADAMS COTTAGE. The Fordyce Photo Collection contains many photographs of Larchmont Manor houses and vistas. Some are readily identified, such as this dwelling at 15 Woodbine Avenue. It was built by Oliver Adams, a member of the Larchmont Yacht Club since 1881 and a summer resident of Larchmont since 1888—the probable date of construction of this house. Adams was described in the local press as "the representative of an English syndicate for placing money in car trusts." Notice the horsecar tracks running down Larchmont Avenue in the foreground.

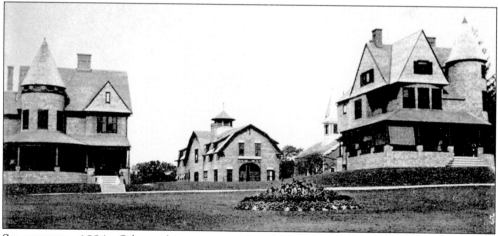

SOMEWHERE, 1894. Other subjects cannot be identified. Some probably remain but are unrecognizable because they have been shorn of their Victorian decoration and covered with asbestos shingles, stucco, or aluminum siding. The landscape, too, has changed. Much of Larchmont Manor was treeless in the early days, with many small streams and marshes and streets that were narrow and unpaved. The houses at the left and right somewhat resemble survivors on Prospect Avenue, but the two buildings between and behind them are a complete mystery.

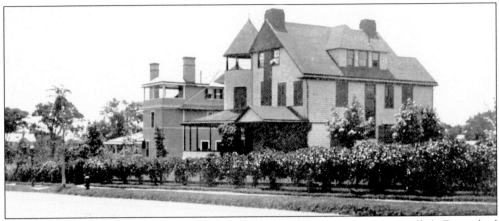

THE EATON AND WIGHT COTTAGES, 1893. William Henry and Mima Griffeth Eaton had a summer home (right) at 40 Prospect Avenue. William Eaton was manager of the Liverpool, London and Globe insurance company and president of Globe Indemnity Company, Factory Insurance, and the Board of Fire Underwriters. George Richards Wight had a home (left, partial view) at 34 Walnut Avenue, which is now much changed. Wight was president of the Lorillard Refrigerator Company, senior partner in G.R. Wight and Company, and the first president of Larchmont Village.

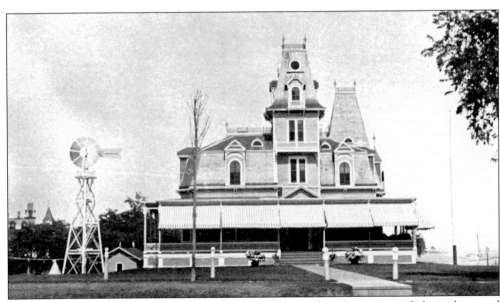

ON THE WATERFRONT. This unidentified waterfront house has almost certainly been destroyed because nothing remotely resembling it can be found. The windmill was probably used for raising water to a tank on the roof or possibly in the tower to the right.

THE LOCKETT COTTAGE. The house at 41 Beach Avenue was built in 1893 for Alice and Benjamin Lockett. Lockett was a New York City dry goods merchant and a commodore of the Horseshoe Harbor Yacht Club. The house served from 1959 to 1992 as the rectory of St. John's Church.

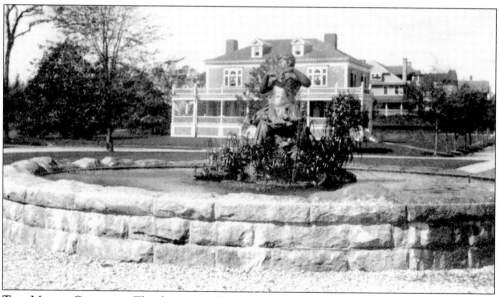

THE MORSE COTTAGE. This house was built in 1891 for Edwin W. Morse on the west side of Fountain Square, where St. John's Church now stands. When the congregation decided it wanted that site for its new church, Morse, a parishioner, obligingly moved his new cottage to its present location, at 20 Linden Avenue, the original site of All Saints Chapel. Then, he sold it to Henry A. Van Liew. Morse was editor of Scribner's *The Book Buyer* and a member of the board of trustees of Larchmont Village. Van Liew was president of the Oriental Silk Company and Fine Arts Designs.

APRIL ON THE ROCKS, 1904. Two members of the Fordyce family, well bundled up against the sharp April winds off Long Island Sound, take a rest near one of the summerhouses. Unlike most of the houses in Larchmont Manor, the Fordyce Cottage had been constructed as a year-round home, with central heating and other amenities. Thus, the family sometimes came to Larchmont earlier or stayed later than other cottagers. Some photographs in the collection even show Manor Park, Fountain Square, and other sites knee-deep in snow.

SWEET 17, MAY 1904. Emma Fordyce, age 17, strolls at the eastern end of Manor Park.

GET A HORSE! Although a few mossbacks had objected to the introduction of electrical service in 1894 as a fire hazard, they failed to perceive the real threat it posed to the cottagers' way of life: cheap commutation from New York City. The various electric railway companies that were fiercely competing for control over lower Westchester were not so dim, however, and seven months after Charles Murray's generators went into operation, an application was made to run a trolley through Larchmont on the Boston Post Road. The cottagers were violently opposed. "We grant a franchise and we get in return what? A trolley road that none of us would patronize and a ruined driveway [the Post Road] absolutely despoiled of all its beauty and usefulness," one wrote in the local press. Then he added the clincher: "Bring a trolley line into our midst direct from New York and what becomes of our seclusion; our privacy; our peace of mind? How many trips will the hoodlums and roughs make from the city before they discover that Larchmont is an attractive place on a Sunday afternoon?" At a public meeting in 1899, Dr. John Fordyce delivered the ultimate threat: he would, he said, "sell his property if the trolley came and move to a quieter summer resort." The trolley finally came—in 1900—and Dr. Fordyce did sell out and move, but not until 1911. Addison Fordyce (above), at about age 11, poses at the wheel of the family's new runabout. The sewing room (below) was on the third floor of 20 Maple Avenue.

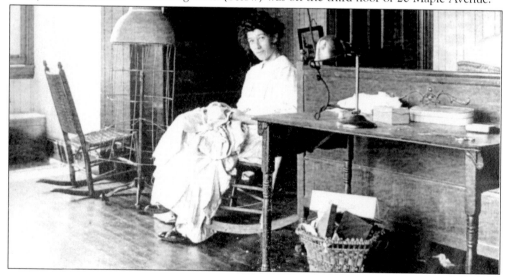

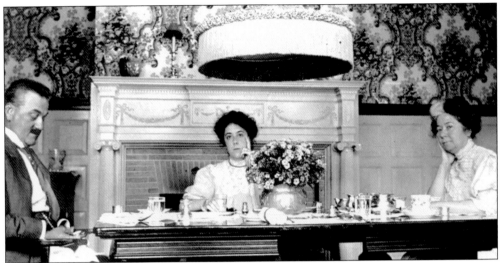

AN INTIMATE DINNER. John, Emma, and Alice Fordyce share an introspective moment at their dining table in 1909. Dr. Fordyce appears to be consulting his pocket watch. Is he late for an appointment? Has he rigged up a self-timer on his camera? Is Addison Fordyce manning the box camera for a rare photograph not taken by his father? We will never know.

THE NEXT GENERATION, JULY 2, 1911. Emma Fordyce sits on the front steps of 20 Maple Avenue with her husband, Mr. MacRae, and their firstborn child, Alice. Shortly after this photograph was taken, the family left Larchmont. The home at 20 Maple Avenue was purchased by Frederick F. Fitzgerald, president of the American Locomotive Company and the Larchmont National Bank and Trust. It was extensively remodeled by Fitzgerald's architect son-in-law, W. Kenneth Watkins. Interestingly, the interior was left almost intact and is recognizable in Fordyce photographs. Dr. John Fordyce died in 1925 and was buried from his home at 8 West 77th Street in Manhattan. A longtime Larchmont resident recalls that Addison Fordyce also became a doctor, married a woman named Ann, and lived in Westport, Connecticut. Best efforts to locate descendants of this family have so far been unavailing.

Four

FROM THE NEW CENTURY THROUGH THE GREAT WAR

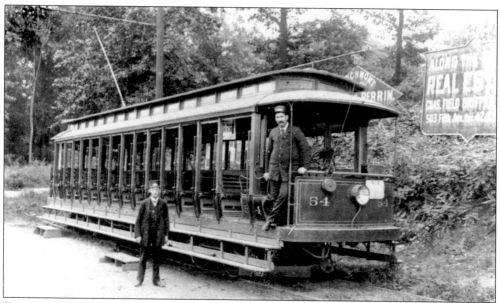

THE MODERN MENACE. John Hickey, motorman, stands at the helm of a new electric trolley at the station. The conductor is unidentified. In the background are two real estate billboard advertisements: Perrin in Larchmont and Charles Field Griffen in New York City.

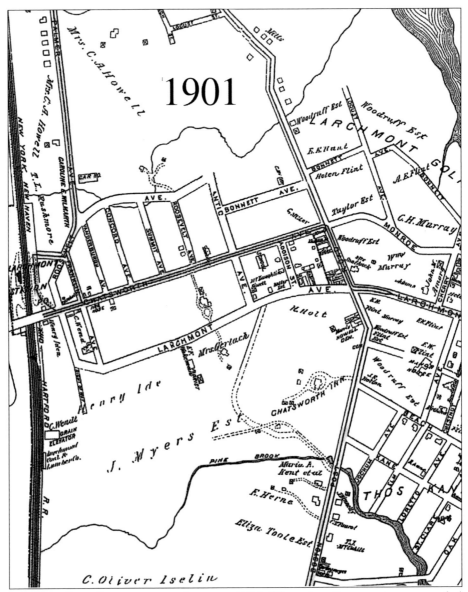

BETWEEN THE POST ROAD AND THE STATION, 1901. When the village was incorporated, there were 110 buildings in Larchmont Manor and only 15, including commercial properties and the Chatsworth Inn, between the Post Road and the railroad tracks. In 1901, that number had grown to only 25. The large house between Larchmont and Chatsworth Avenues belonged to Carsten Wendt, and except for Mary Gerlach's, appears to be the only residence in this area. Carsten Wendt, a German-born New York City attorney, had purchased 30 acres of Chatsworth Land Company property in 1885, and in 1893, he built a cottage on it. He was the second president of the village. Mary Gerlach, owner of the second residence depicted on this map, immigrated to America from County Tipperary in 1870 and immediately moved to Larchmont, where she lived on the Myers estate with her first husband, Steven Keller. In 1881, she purchased the property shown on this map, and some 10 years later she married Julius Gerlach, a German-born house painter. She sold her property in 1906 to the Nouveau Realty Company of New Rochelle, which developed it as Utopia Park, with a street named Gerlach Place.

96

CYRUS HARPER. Larchmont-born Cyrus Harper (b. 1867), son of George Vanderburgh's coachman Thomas Harper, established at the station the first hacking service, a horse-drawn surrey. He also drove a Rockaway hack, a special type of carriage with curtains, which he used to carry the theater people who summered in Larchmont Manor. He later replaced his horse-drawn carriages with a Palmer-Singer automobile (c. 1908) and a Pierce Arrow (1921). Harper was elected town constable in 1900. He was still meeting commuters at the station in 1949 at the age of 82. He attributed his health and longevity to "good eating, good drinking, good thinking, and minding my own business."

THE GREAT FIRE. Headlined in the *Larchmonter* as "The Most Disastrous Fire in Larchmont's History," the business district fire of Sunday, November 2, 1902, remains so to the present day. Most of the buildings on the block of Larchmont Avenue between the Post Road and Addison Street burned to the ground, as did much of the adjacent portion of the Post Road and backyard barns and stables and the auxiliary firehouse. The fire was finally extinguished by the fire engine from neighboring New Rochelle. "The local department was considerably hampered by the unfortunate absence of its own engine, which is in Seneca Falls for repairs," the *Larchmonter* pointed out with characteristic understatement. The fire led to an amendment of the fire ordinance forbidding the construction of wooden buildings in the business district.

KUHNAST GROCERY, 1911. Herman Kuhnast (second from the right) recovered and rebuilt his grocery business. His son stands to his left. The Kuhnast emporium was a branch of what would now be called an upscale grocer in Manhattan.

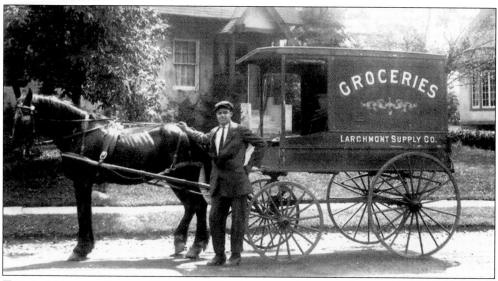

THE LARCHMONT SUPPLY COMPANY. The first general store in Larchmont, the Larchmont Supply Company was established by Edward Burtis and William Palmer near the railroad station c. 1885. By 1900, it was thoughtfully providing delivery service to residents in all parts of the village.

THE MANDEVILLE BLACKSMITH SHOP. Phillip Mandeville—a surname still represented in Larchmont—shoed horses somewhere in the village. Serving a purpose in those days that automobiles supply in our own, horses, carriages, and their needs usurped a corresponding amount of space. In 1900, every dwelling of any consequence had its own carriage house, and the two business districts (on the Post Road and at the station) were occupied largely by stables, blacksmiths, harness makers, carriage dealers, and feed stores. Almost all of this had been accomplished since incorporation.

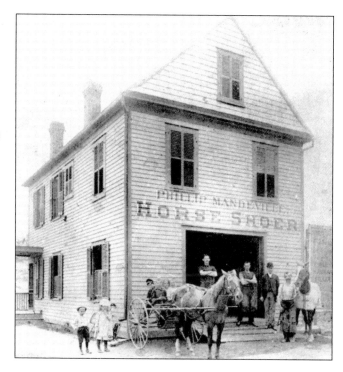

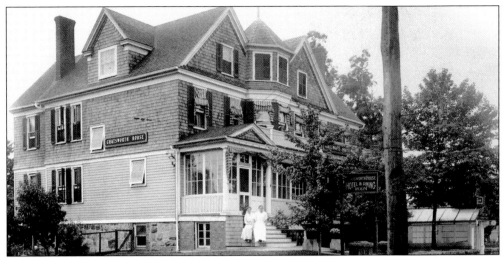

THE CHATSWORTH HOUSE. Roadhouses thrived along the Boston Post Road with the advent of the automobile. Some of them closed their doors upon passage of the National Prohibition Act (1919), but others flourished. One of the latter was the Chatsworth House, at the corner of Palmer and Chatsworth Avenues. Built in 1900 by Michael DeCicco, a major local public works contractor, it served as a family-run restaurant and workers' hostel. Local legend has it that it was also the site of the first meeting of Theodore Roosevelt's Bull Moose (Progressive) party. Later, as Abe Levine's Larchmont Lodge, it became an attractive speakeasy. When Prohibition was repealed (1933), the establishment transformed itself into an upscale restaurant attracting diners from New York City as well as locals. It was razed in 1977-and replaced by a four-story office building at 1890 Palmer Avenue.

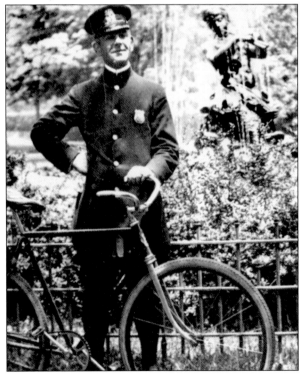

WILLIAM J. KERESEY. The second order of business taken up by the inaugural village board was police protection (the first was improving the roads). This was accomplished by hiring Richard Restore as constable at a salary of $60 a month—a princely sum. By 1896, Larchmont boasted "the only uniformed police force [three men] between New Rochelle and Stamford, Connecticut." In 1898, the village's five policemen were given bicycles to improve the odds of their apprehending speeding "wheelers." William J. Keresey was appointed bicycle patrolman in 1914. He served 60 years in the department, 41 of them as chief, an office in which he was followed by a son and grandson. The three Kereseys—William J., Jack, and William J. III—served an aggregate of 115 years in the Larchmont Police Department.

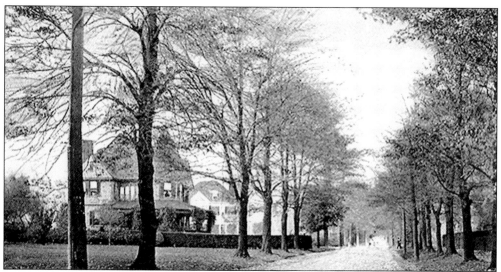

WOODBINE PARK. Thomas Kane came to America at age 15 and made a fortune in the contracting and fertilizing businesses. He invested much of his wealth in real estate both in New York City and Larchmont. As property values soared in Larchmont Manor, Kane cast an appraising eye on the 50-acre farm he had bought from Edward Knight Collins's widow in 1876. He engaged the Manor Company's engineer, Frank Towle, to survey the farm and lay it out in suburban villa plots. Seen here at left is 92 Beach Avenue, one of the first dwellings erected in Woodbine Park, where development lagged for a decade because of lack of sewers and water mains. Kane made large donations to charitable causes and was particularly supportive of St. Augustine's Chapel. Many of his children, grandchildren, and nephews settled in Larchmont or Mamaroneck, where they were active in commercial and governmental affairs.

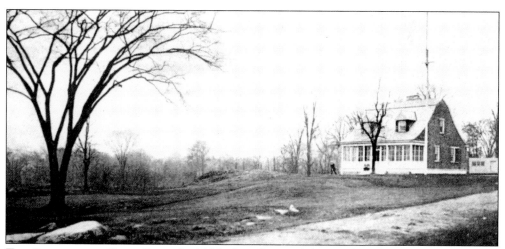

THE LARCHMONT GOLF CLUB. In 1895, the officers of the Larchmont Yacht Club signed a lease with Helena and Adele Flint to lands lying between the club and the Post Road, with the intention of laying out a nine-hole golf course for the use of its members. Two years later, Charles A. Singer, a member, built a small golf house and sold it to the club, specifying that the sale included the building only, no land. It was in fact moved several times before 1909, when the Flints reclaimed the property. Moved again, enlarged, and much remodeled, the golf house survives as a private home at 44 Monroe Avenue.

THE MANOR SCHOOL. This 27-room house was built in 1890 as the home of William Campbell, superintendent of the Larchmont Manor Company. From 1906 to 1925, it served as the Manor School, a private residential school for girls. Upon the school's demise, two separate houses were created by razing the midsection of the building. The front portion of the original structure (below) was razed in 1940 and replaced by a new house at 23 Prospect Avenue. The rear portion (above, first-floor interior) survives as a private residence at 5 Maple Avenue. This was a rental house during the Depression, and the actress Claire Trevor lived here with her family when she was a teenager.

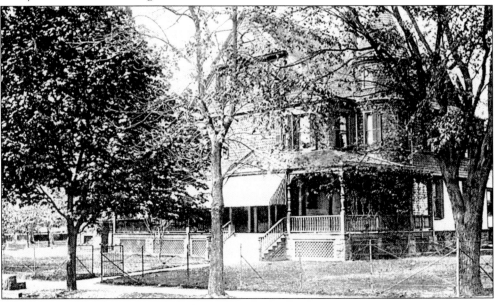

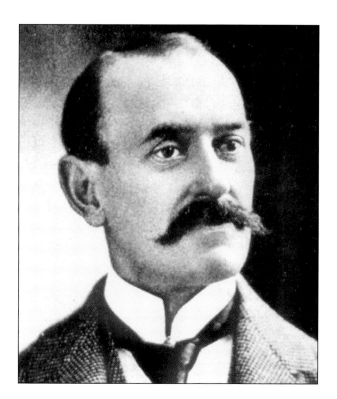

CHARLES PRYER. John Pryer acquired the Motts' house and millpond property sometime before 1867. Upon his death, his son Charles Pryer took up residence. The son was described by his biographer as a political conservative, a social leader, a director of the Knickerbocker Press, and a commodore of the New Rochelle Yacht Club. He was also a member of the Larchmont Yacht Club, the author of numerous books and articles with historical themes, and—like his father—an avid collector of antiquities.

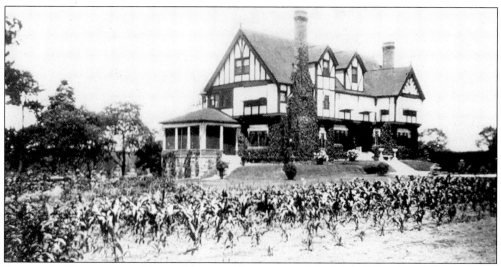

SCHAEFER COTTAGE, IN PRYER MANOR. The home of Rudolph Schaefer of the Schaefer Brewing Company was built in 1903 on land purchased from the Pryer estate. The estate, much of it planted to corn, surrounded the Revolutionary-era Mill House and pond. Although the first division of the Pryer estate took place in the early 1890s, development on the Larchmont side did not begin in earnest until 1904. The remainder of the Pryer (formerly Mott) property, on the New Rochelle side of the Premium River, was to a large extent low and marshy, and development did not proceed there until after 1920, when some 37 acres were purchased by the realty firm George Howe and Associates. Both areas are now commonly referred to as Pryer Manor.

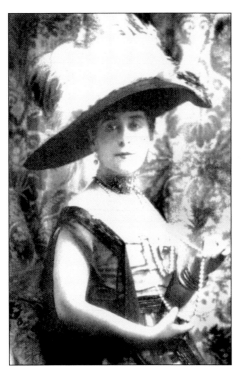

AMY CROCKER ASHE GILLIG GOURAUD MISKINOFF GALATZINE (1863–1941). The exuberant, well-traveled, and much-married daughter of Edward Bryant Crocker of California railroad-baron fame, Amy Crocker, arrived in Larchmont c. 1894 with her second husband. They took up residence in the old Flint Cottage on Oak Bluff (then a landscape feature, now the name of an avenue), a gift from her widowed mother Margaret Crocker, who had purchased this and adjacent property in 1893.

HENRY M. GILLIG. Biographical information on Amy Crocker's second husband is scant, and mention of his occupation is confined to "yachtsman." He was born in California, as was Crocker, where they met under circumstances that made a good story in the press but are not necessarily true. It was said that Gillig was a friend of Porter Ashe (usually described as "a horseman"), and both ardently courted Crocker. At last, the three agreed to settle the rivalry at the game table, where Ashe won Crocker's hand at poker. They were married and had a daughter, Gladys, but by 1889, Crocker had divorced Ashe and married Gillig. He served as commodore of the Larchmont Yacht Club in 1895–1896. By 1900, she had tired of Gillig, also, and she soon replaced him with the love of her life, Jackson Gouraud, a pianist, minor composer, and all-around bon vivant, well connected with cafe society.

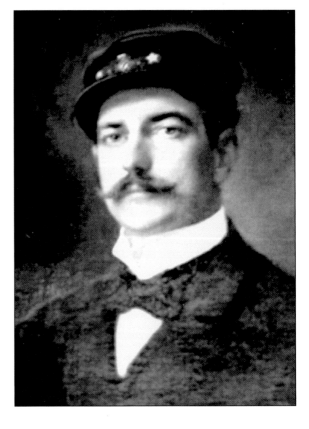

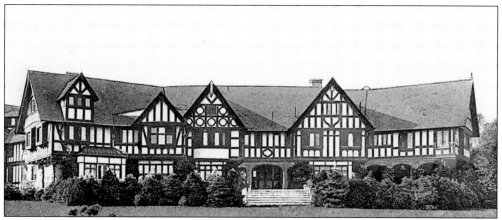

LA HACIENDA. While Jackson and Amy Gouraud were wintering in Paris in 1904, their Larchmont home burned to the ground. Within a year, they had built an even larger and more luxurious replacement—a masterpiece of Tudor architecture to which they quaintly gave a Spanish name. The couple occupied La Hacienda during the summers and, with the help of some 36 servants, gave lavish entertainments attended by celebrities both great and small. After Gouraud's death in 1910, Amy resumed traveling abroad. In 1914, she sold La Hacienda to Rudolph Schaefer, who renamed it Beechlawn. The Schaefer family sold the house in 1925 to the Glendevon Corporation, which turned it into the Larchmont Shore Club.

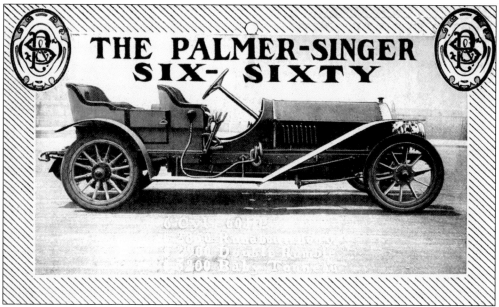

THE PALMER-SINGER SIMPLEX, 1908 ADVERTISEMENT. Charles A. Singer, a Larchmont resident since at least 1888, and Henry W. Palmer (possibly a descendant of Larchmont's first settlers) were partners in the Palmer-Singer Auto Company. By 1909, the Palmer-Singer was one of the best-known luxury cars in America. After Palmer died, Singer along with his son Charles Jr. and H.R. Callisen formed the Singer Motor Company and produced cars until 1920. Singer was also a partner in the Larchmont Manor Horse Railway and later in the New York and Stamford Electric Railroad.

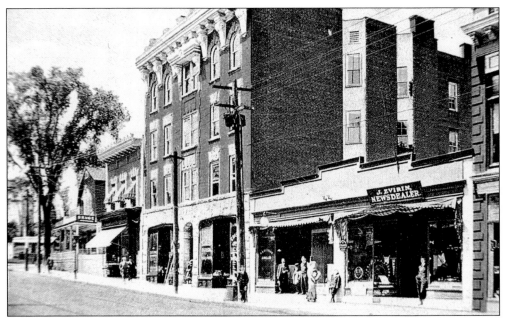

THE POST ROAD BUSINESS DISTRICT, C. 1910. During the golden age of the cottagers, commercial ventures were confined to the railroad station area, and they were few in number: three boarding stables, two blacksmiths, a carriage dealer, harness makers, and Edward Burtis's general store, where he and William Palmer (a descendant of the first settlers) sold groceries, feed, coal, lumber, and cider. Until 1890, Thomas Palmer cut hay in what soon after the incorporation of the village became the Post Road business district.

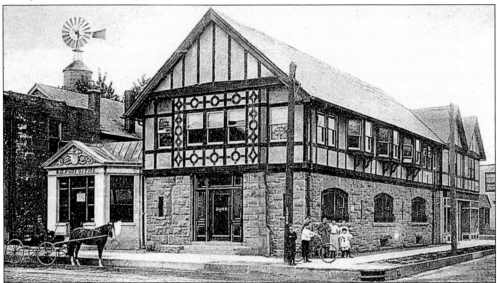

THE LARCHMONT NATIONAL BANK AND POST OFFICE. Larchmont's first post office was in the old Carpenter-Gothic Chatsworth Railroad Station. The post office moved to this building when it was erected in 1908 at the northwest corner of the Boston Post Road and Chatsworth Avenue. Note the windmill and water tower (left background), served by an artesian well that formed the backbone of the Larchmont water supply before the Larchmont Water Company began installing its mains in 1889.

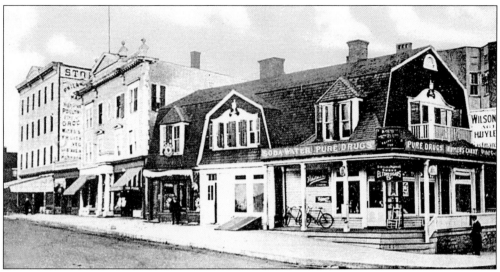

BULL, FISH, AND MARVIN, KUHNAST AND QUIGLEY. This was location of the 1902 fire about 15 years later. The second building from the left, Bull Building No. 1, survived the fire and is extant today. The Fish and Marvin Building on the right corner was replaced in 1923 by Larchmont's first steel-framed structure. The building at the far left, the Kuhnast and Quigley Market, was erected almost as soon as the ashes cooled. It was razed in 1926 and replaced with a three-story apartment building with street-level shops.

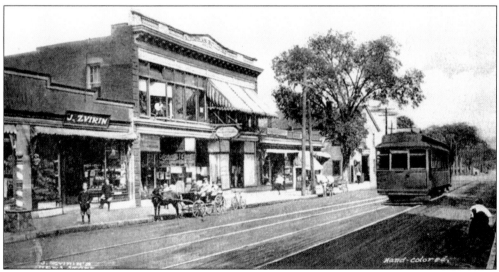

THE NORTH SIDE OF THE POST ROAD, C. 1911. Jacob Zvirin conducted a stationery shop on this and nearby sites from 1900 until well past 1925. He was a printer for the *Jewish Daily Forward*, a frequent candidate for local political office, and the father of Phil Severin (d. 1986), a Larchmont realtor and local historian. At some point Zvirin's shop moved into the Metchan Building next door, built in 1891 and greatly remodeled in the late 1980s. Notice the electric trolley—the overhead wires have been retouched out of the picture.

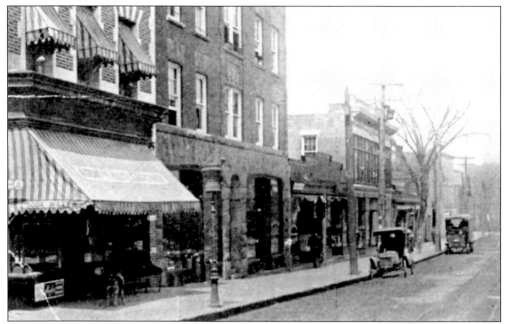

BULL No. 2. The two-story building (left) was erected in 1890 by William R. Bull, a dairyman who expected a commercial real estate boom to follow the imminent incorporation of the village. It has housed Wilson's, Buck's, and Hughe's pharmacies (the latter holding on until the late 1990s). The four-story, brick-and-granite structure next door was built in 1904.

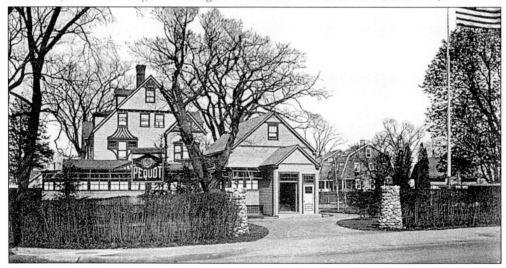

THE SOUTHACK COTTAGE, OR THE PEQUOT INN. This building at the southeast corner of the Post Road and Larchmont Avenue was the home of Julia Southack, daughter of Larchmont Manor Company partner Marcus Woodruff. The Southack Cottage was rented for several seasons by actor John Gilmour. It became the Plymouth Inn c. 1910, and it had been through several names, including the Pequot, by 1917. In 1922, the property was bought by Edward F. Albee, vaudeville tycoon and Larchmont benefactor, "for the express purpose of beautifying one of the most important corners in the Village." This building and its fine stand of elm trees were destroyed to make way for the Albee Court Apartments and the Albee Bank Building (now the Beth Emeth Synagogue).

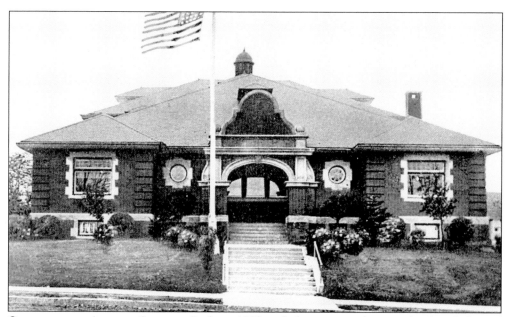

CHATSWORTH AVENUE SCHOOL. Built in 1902 with four rooms, this was the first dedicated elementary school in the Mamaroneck School District. It was soon enlarged by a two-story rear addition, and in 1922, two stories were added to the original wing.

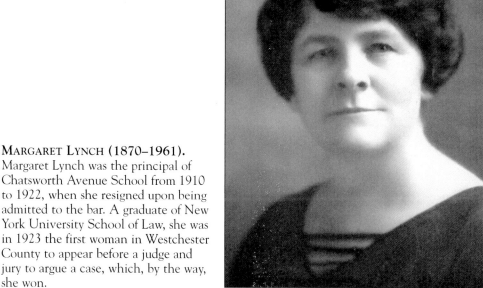

MARGARET LYNCH (1870–1961). Margaret Lynch was the principal of Chatsworth Avenue School from 1910 to 1922, when she resigned upon being admitted to the bar. A graduate of New York University School of Law, she was in 1923 the first woman in Westchester County to appear before a judge and jury to argue a case, which, by the way, she won.

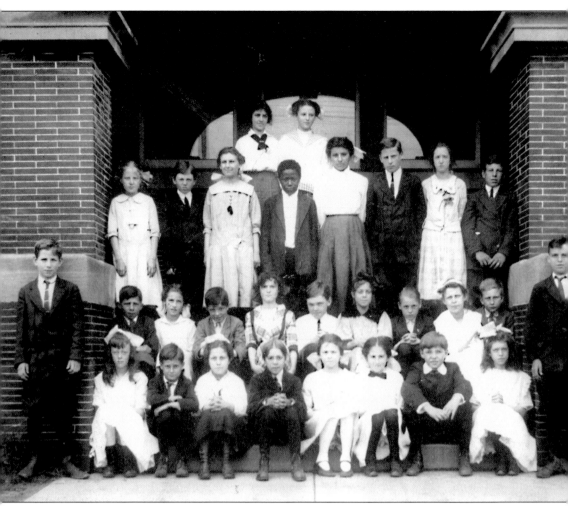

CHATSWORTH PUPILS. This photograph is undated and the children unidentified. Because there are two teachers and the students appear to be of various ages, this may be the entire student body. The pupils' clothing also suggests an early date—c. 1905, perhaps?

BEACH AVENUE AT BOSTON POST ROAD. The first development north of the Post Road, part of what is called Pinebrook today, was then known as Larchmont Park. The first phase of development occurred in 1905, and the second began in 1914. Shown are the first houses built in the subdivision, in 1905–1906, standing on Bayard Avenue. The land had been the 84-acre James Myers estate, and his 29-room summer cottage—later the Chatsworth Inn—stood about where the middle house in this photograph stands.

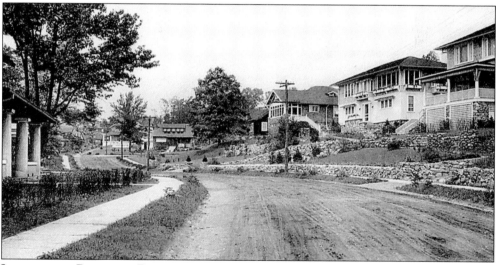

LARCHMONT PARK, OR PINEBROOK. Mayhew Avenue, one of the first streets developed in Larchmont Park, was named in honor of local benefactor Mayhew Bronson. Unlike the marketers of Larchmont Manor and Woodbine Park south of the Post Road, the Larchmont Park realty company built year-round houses on speculation, sold them "on easy terms," and advertised that the property was "far enough removed from the waterfront to prevent it from having any of the bleak unattractiveness of actual shore property during the winter months."

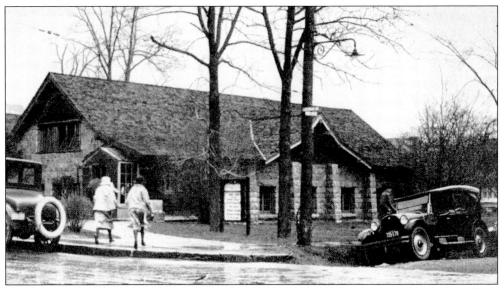

THE LARCHMONT AVENUE CHURCH. This congregation was founded in 1914 by Emily Earle Lindsley under the auspices of the Presbytery of Westchester, but it has always been a community church patronized by Protestants of many sects. Ground was broken in 1915 on land at the corner of Larchmont and Forest Park Avenues, the basement was dug, and the congregation ran out of funds; so, they covered the basement with a shingled half-story (shown). The parish house and sanctuary were not completed until 1930, to designs by Otto Eggers, a member of the firm of John Russell Pope. Deep in the Depression, the congregation met mortgage payments with donations of jewelry, silverware, and gold eyeglass frames.

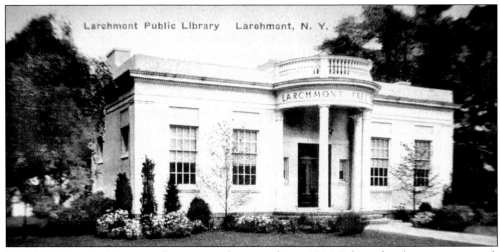

THE LARCHMONT LIBRARY. On or near this site, the *c.* 1701 Palmer farmhouse once stood. The library was built in 1924, with funds raised by a coalition of citizen groups, on land donated by vaudeville tycoon and local benefactor Edward Albee. It stood empty for two years, "a bookless monument," until the village of Larchmont and the unincorporated town of Mamaroneck reached an agreement for its operation. Frank Moore was the architect; at about the same time, he also designed the adjacent Larchmont Village Hall, the Albee Bank, and the Albee Court Apartments.

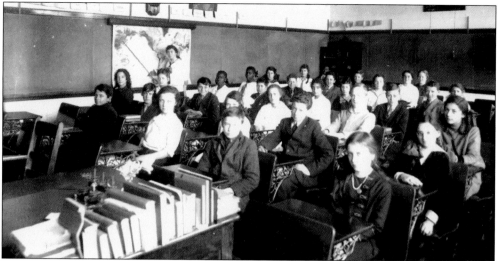

OLD CENTRAL CLASS. A roomful of well-dressed pupils in the building erected in 1888 as the Mamaroneck Free and High School is identified only as "old Central class." After 1925, when a new high school was built, the original building became Central Elementary School. This photograph seems earlier, however, so perhaps it dates from the earlier years when the building served all grades from 1 through 12.

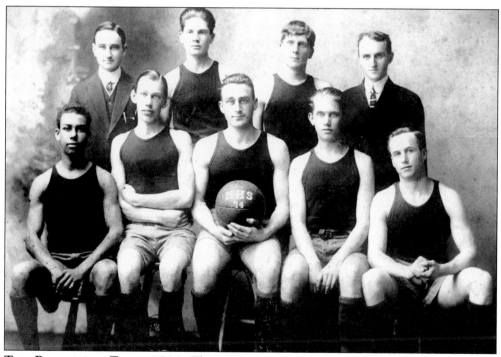

THE BASKETBALL TEAM, 1914. This Mamaroneck High School basketball team would have taken classes in the original Mamaroneck Free and High School building. Otherwise unidentified, the first-string players are seated while their coaches and two alternates stand behind them. It is likely that some of these boys were among the 182 Larchmonters who served in World War I or, as it was then called, the Great War.

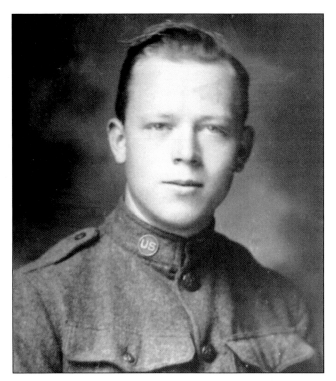

FRANK BRANAGAN. In 1892, the Reinstein family moved to Larchmont and bought the Larchmont Hotel by the station. The Reinsteins' daughter Marie was born the same year. She married John Francis "Frank" Branagan, seen here in his World War I uniform. He returned safely from the war and worked with his father-in-law at the hotel.

JOYCE KILMER. Long before his untimely death at the Second Battle of the Marne, Joyce Kilmer wrote one of the most popular American poems of all time, "Trees." For more than 80 years, virtually every noble tree in Larchmont has been pointed out by someone as "the very one" that inspired the poem. In fact, the poem was written in New Jersey. Kilmer moved his family to Larchmont just before he enlisted. He was hailed a national hero as "the only poet of established reputation to fall fighting in any American war," and in 1923, a Larchmont street was named in his honor. Other local men killed in the war were John Fay, John Lyons, John Isbister Jr., Charles J. Cuminskey, Ulises O. Daymon, Harry Dudley, and Charles S. Clarke. Streets were also named for Daymon, Lyons, and Clarke.

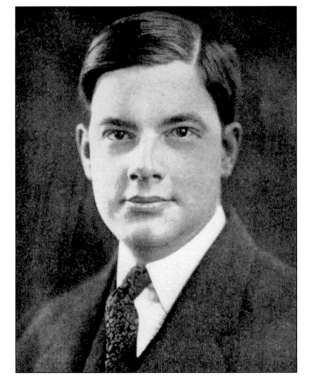

A Red Cross Volunteer. Larchmont women signed up as volunteers in great numbers, and they often brought their daughters with them into the home-front war effort. June Freeman accompanied her mother, Mabel White Freeman, to Red Cross meetings, which featured bandage rolling and the knitting of gloves, socks, and scarves.

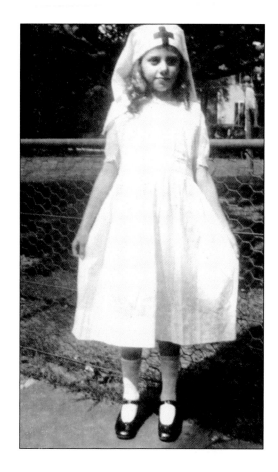

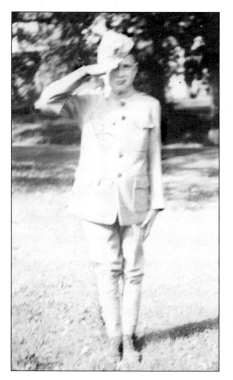

A Little Soldier. Vincent Kane, about age six, delivers a smart salute. Perhaps he was among the local children who aided the war effort by making a census of black oak trees that could be cut down to make propellers for aircraft. He was the grandson of Thomas Kane, developer of Woodbine Park, and the son of Peter F. Kane, a frequent candidate for public office.

THE KRUPP CANNON. Behold Dick Murphy in 2000, sitting where he sat as a toddler nearly 80 years before. It is impossible to find anyone who grew up in Larchmont who did not play on the old cannon in Flint Park. But few have paused to notice exactly what it is (a Fred Krupp armament manufactured in Essen, Germany, in 1893) or how it came to rest in Larchmont (as a World War I trophy requested of the secretary of war by the Larchmont Village Board). By the year 2000, the wheel spokes had separated from the rim, presenting a safety hazard. At Murphy's prodding, the village board and the Larchmont Historical Society shared the cost of metal repairs, and a past president of the society, Rob Snedeker, volunteered the millwork. This old engine of death, beaten by generations of children into a plaything, is now on its second century, as seen in the 2002 photograph below.

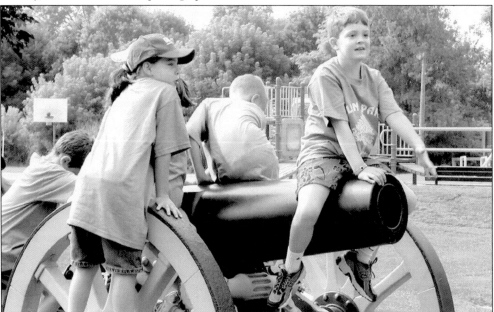

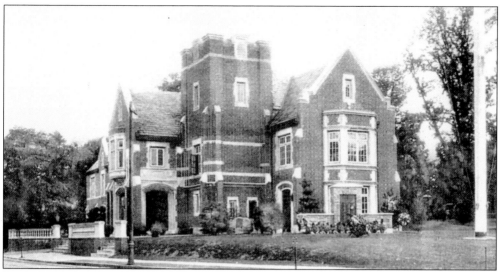

THE NEW VILLAGE HALL. The Larchmont Village Hall, Firehouse, and Police Department Building was designed by Frank A. Moore, a longtime village resident. Tradition holds that the land was donated by Edward F. Albee, president of the Keith-Albee-Orpheum Circuit of Theatres and a 20-year resident of Larchmont. The cornerstone was laid by his wife, Laura Smith Albee, on July 19, 1922. The granite World War I memorial and an unusually tall wooden flagpole—both now gone—were erected at the same time.

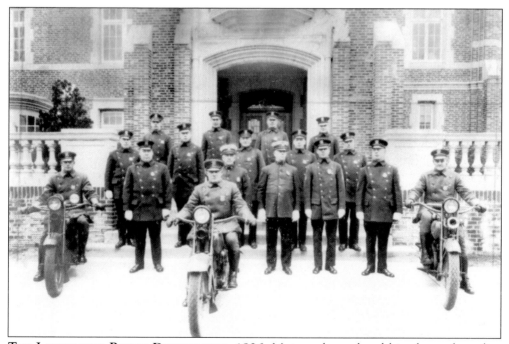

THE LARCHMONT POLICE DEPARTMENT, 1926. Motorcycles replaced bicycles as the police department's mode of transportation in 1918. By that time, motorists were the ones who needed chasing down, not cyclists.

THE STATION AREA BUSINESS DISTRICT. The earliest business district grew up around the railroad station, and the businesses that continued to flourish there were not of the type that make for a tidy appearance—stables, blacksmiths, lumber dealers, cider mills, feed and seed stores, and the like. The site pictured here disappeared sometime between the flurry of station-area renewal in the late 1920s and the New England Thruway in the 1950s. In the early 20th century, it was the horse barn of Edward Clone, owner of the Larchmont Ice Company. As cars replaced horses, garages moved into former stables. By 1920, Michael Crimmins had converted the barn into an auto repair shop offering gas, air, welding, and magneto starters, according to the legible signage.

FRANK BRUNO'S TAXI SERVICE. More or less across the street from Crimmins's garage stood a building housing Frank Bruno's taxi service and shoe repair shop. Bruno, whose father emigrated from Italy in the early 1900s, was a member of a large and enterprising family best known for operating the Larchmont Tavern (at 104 Chatsworth Avenue) for 65 years.

THE REINSTEINS AND THEIR HOTEL.
Peter Reinstein (born in Bavaria in
1863) and Babette Reinstein married
in Germany in 1889 and moved to
Larchmont c. 1892. They purchased
the Larchmont Hotel, around the
corner from Bruno's taxi stand and
near the railroad station. Frank
Branagan, the Reinsteins' son-in-law,
stands in the doorway below. The sign
on the upstairs porch reads "Buses
leave here for Rye and Oakland Beach.
Fare 35¢." It is uncertain whether
the hotel's name was ever formally
changed, but it was referred to in the
press and elsewhere as Pete Reinstein's
Saloon and Bowling Alley. He closed
its doors shortly after 1920, following
passage of the National Prohibition
Act, and the building was razed in
1925.

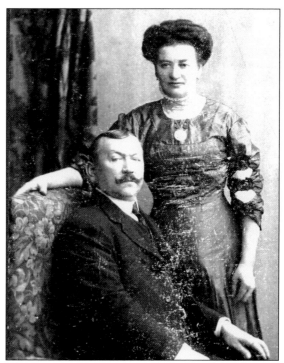

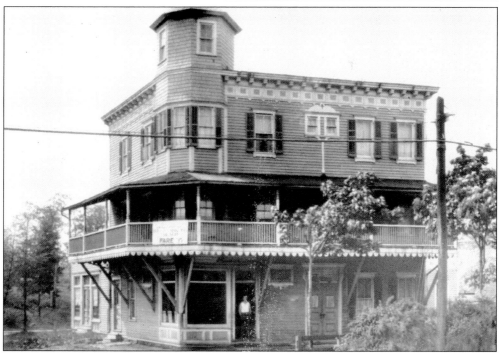

MURRAY AVENUE AFTER BEAUTIFICATION. With the expectation (never realized) of the Pelham-Port Chester Parkway and plans announced in 1923 for the Hutchinson River Parkway (completed in 1928), the Westchester County Parks Commission offered commuters "a scheme of pleasant automobile transportation to and through the county." This opened the six square miles of the unincorporated town of Mamaroneck to development; commuters could drive to work or to the station. The area just north of the railroad tracks was rebuilt, as seen here. Apartment buildings and wide streets replaced the old stores and tenements, creating a gentrified entry to new subdivisions in "the Heights" above the station. Development started early in Larchmont Gardens and Larchmont Woods but proceeded most rapidly after World War I, as was the case with the rest of the unincorporated area.

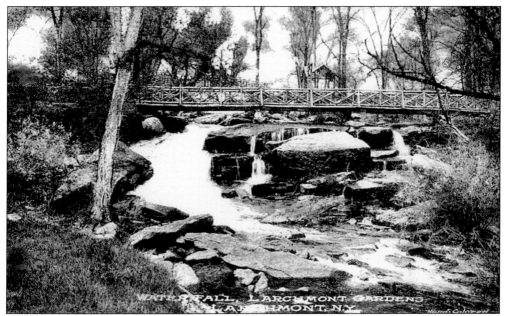

LARCHMONT GARDENS. The falls of the Sheldrake River was the early 19th-century site of Mott's Spool Cotton Mill. Hickory Grove Drive, at the head of the falls, took its name from the Motts' farm in the area. Development of the 140-acre subdivision began in 1911, spurred by the proposed (but never built) Pelham-Port Chester Parkway and of the New York, Westchester, and Boston Railway (finally built in the 1920s but bankrupted by the Depression).

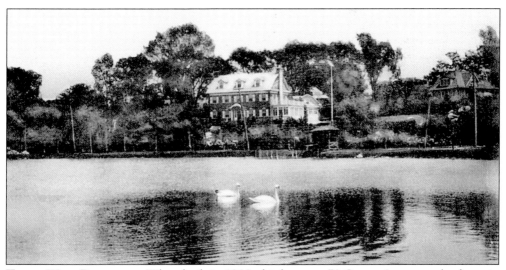

THE deWILD RESIDENCE. When built in 1920, this house at 72 Cooper Lane was the finest in Larchmont Gardens. It was built by Carol F. deWild, an artist, on a two-acre lot overlooking the man-made Larchmont Gardens Lake. Among its many features were a pipe organ and a 32-line switchboard. Both Larchmont Gardens and the adjacent Woods of Larchmont were developed by aviation pioneer Clifford B. Harmon as the first subdivisions in the rocky hills above the New Haven Railroad tracks. Like Larchmont Park, these neighborhoods were built for year-round residency.

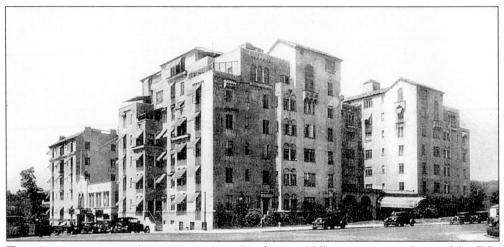

THE ADVENT OF THE APARTMENT AGE. Larchmont Hills Apartments, designed by E.D. Parmelee and built in 1925, initiated the upgrading of the station area, which was made possible by a then recent rezoning of this business area to permit apartments. Memorial Park, too, was laid out at this time, as were the adjacent shopping strip on Myrtle Boulevard and the former Longines Symphonette Building.

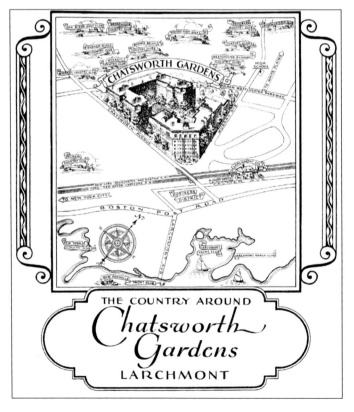

CHATSWORTH GARDENS. Of those moving into the new apartment buildings, one testy member of Larchmont's upper strata snorted, "All they bring with them is a few golf sticks!" That clubs, golf and otherwise, were believed to be a draw is illustrated by this flyer for Chatsworth Gardens, also designed by E.D. Parmelee and built in 1928. The scrolls name 16 clubs, some (like Bonnie Briar Country Club) quite near, others (like the Greenwich Field Club) 20 or more miles away.

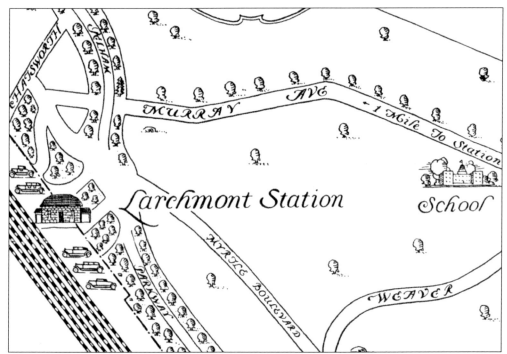

A ROUKEN GLEN ADVERTISEMENT. This 1925 realtor's map of the station area eliminates everything unsightly. The school represented is the brand-new Murray Avenue Elementary School. (Murray Avenue, by the way, takes it name from Charles Murray, who in 1889 had opened a path for his water mains through the woods from the Larchmont Reservoir into Larchmont. The avenue was subsequently laid out over the mains).

AN EARLY HOUSE IN ROUKEN GLEN, 1926. This view of the Wheelock residence, at 11 West Drive, gives a good idea of the neighborhood, which was developed at the height of the popularity of the Tudor style. The name Rouken Glen—based on the Old English words for castle and valley—seems an odd choice for a development perched on one of the highest points in the town of Mamaroneck. Shown is the rear of the house, overlooking East Drive. Notice the stone "gates" on either side of the road leading down to Murray Avenue.

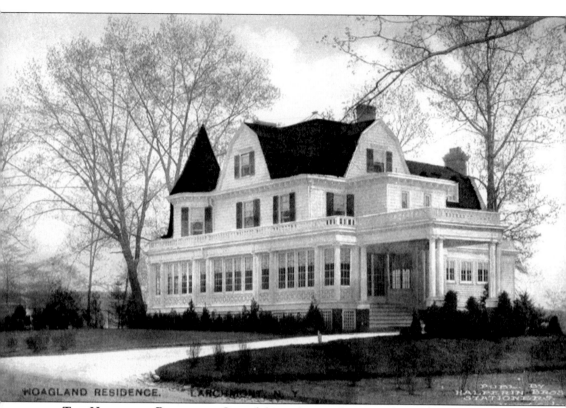

HOAGLAND RESIDENCE. LARCHMONT, N. Y.

THE HOAGLAND RESIDENCE. One of the earliest and most striking houses in the town stands at 59 Edgewood Avenue. It was built sometime before 1901 for Dr. and Mrs. Thomas O. Taylor. John Hoagland, a man of leisure, came into his inheritance in 1911 at the age of 40, purchased the house, and expanded it greatly. He was the son of Joseph Hoagland, who with his brother Dr. Cornelius Hoagland founded the Royal Baking Powder Company (1873), which they built through skillful advertising into the largest and most lucrative manufacturer of baking powder in the world. In 1895, they declined an offer of $10 million for the brand name alone. Joseph was a yachtsman, with a steamer the size of a battleship—187 feet—and residences in Brooklyn, Shelter Island, and Seabright, New Jersey.

THE MURRAY AVENUE SCHOOL. The Murray Avenue Elementary School was built in 1922 to meet the demand created by the families moving into the new subdivisions in the unincorporated town of Mamaroneck. It was originally surrounded by woods and meadows, which were obliterated by two large additions in 1926 and 1930 and macadamized playgrounds. Loretta M. Hirschbeck served as principal from 1922 to 1958.

These youngsters made up the fourth-grade class of 1926. From left to right are the following: (first row) Gloria Hatrick (who later achieved a kind of fame as the wife of Jimmy Stewart, a popular movie actor), unidentified, Marjorie Gibson, Phoebe Cole, Ruth Brighton, Astid Bjerken, Leslie Friedman, Arthur Wellschleger, Anthony Poccia, John Twombly, and Henry Kramer; (second row) Anna Tiebout (later the wife of Phil Reisman Jr.), Anita Thompson, Marian McMillan (possibly), Grace Leddy, Robert Johnson, Clark Neal, Jay Wilcox, Alex Spence, and Roger Wernecke; (third row) Irma Dornbusch, Nancy Brown, Peggy Stengl, teacher Ruth Chesbro, Felix Birch, unidentified, and Earl Braisted.

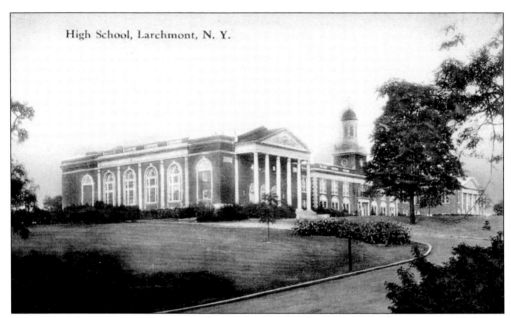

High School, Larchmont, N. Y.

THE NEW HIGH SCHOOL. By 1925, the old Mamaroneck Free and High School building was much outgrown, and a new school was built on Palmer Avenue to accommodate grades 7 through 12. The old high school then became the Central Elementary School.

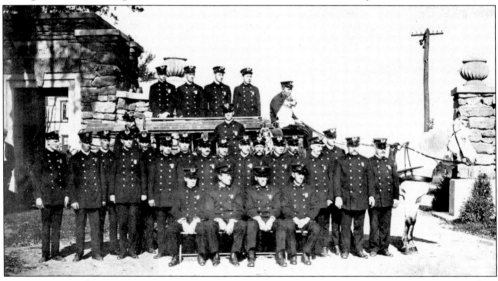

THE WEAVER STREET FIRE DEPARTMENT, C. 1909. Fire Company No. 1 was organized in 1907 with 27 members, a hand-drawn hose reel, 200 feet of hose, and a shack on Weaver Street to house them. The need at that time was largely driven by barn fires. This photograph was taken in front of the entrance to Larchmont Gardens. From left to right are the following: (seated) J.C. Forrar, third lieutenant; George Burton, captain; J.H. Keehler, first lieutenant; and R. Irvine, second lieutenant; (standing) F. McGeough, H. Lockwood, M. Ireland, W. Palmer, J. Moll, H. Brown, G. Dudley, F. Bohem, F. Johnson, T.P. Howell, A. Moll, F.A. Johnson, C. Peterson, J. Kewton, E. McCulley, P. Reinstein, and J. McLaughlin; (on the running board) O. Addor and J. Pendergast; (on the wagon) R. Dudley, J. Moll Jr., J. Forsythe, D. Johnson, and J. Hill, driver. The names of the dog and horse are, unfortunately, unrecorded.

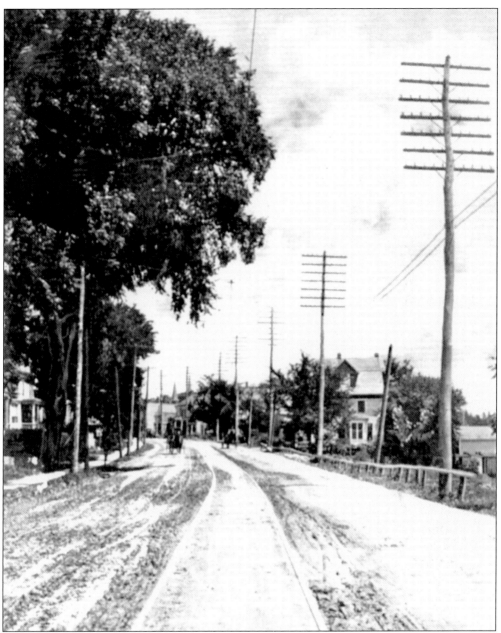

THE END OF THE LINE. After a fierce and complicated battle, in 1900 trolley tracks were finally laid on the Boston Post Road through Larchmont, the last municipality in the county to succumb. With 13¢ and two transfers, it became possible to travel from Larchmont to the Battery (the southern tip of Manhattan), and a mere 5¢ would take you a long way. Yet within less than three decades, the burgeoning popularity of the automobile, along with ever more paved roads built at public expense, made streetcars unprofitable. In the 1920s, General Motors began buying up streetcar systems, pulling up the rails, and substituting rubber-tired, gasoline-powered buses. Exactly when the rails came up in Larchmont is unknown, but it seems to have been in the late 1920s.

FOUNDERS' DAY 1998. On June 25, 1998, founders of the Larchmont Historical Society and a few close friends met at the Horseshoe Harbor Yacht Club to celebrate 18 happy years together. From left to right are the following: (seated) June Allen, founding secretary and a past president; Bruce Allen, longtime archivist; Judith Doolin Spikes, founding president; and Joseph Hopkins; a founding trustee and a past president; (standing) Ralph Santoliquido; Antoinette Sarfaty; Eleanor Lucas, a founding trustee; Mary McGahan; Jim Spikes; Athena Ploumis, founding vice-president; Theora Hahn, a founding trustee; Ray Hahn; Anna Tiebout Reisman; and Phil Reisman Jr. Founders not pictured are Dee Brown, Pat Tripoli, Bill Binderman, Phil Severin, Sherman Totten, Margaret Fraser, Marie Killilea, Tom Flint, Ann Moffett, Marilyn Weigold, Riitta Lagus, Bob Barrett, Betty White, Al Anaya, and Cindy Stoll.